IMAGES
of Rail

THE KEY SYSTEM
SAN FRANCISCO AND
THE EASTSHORE EMPIRE

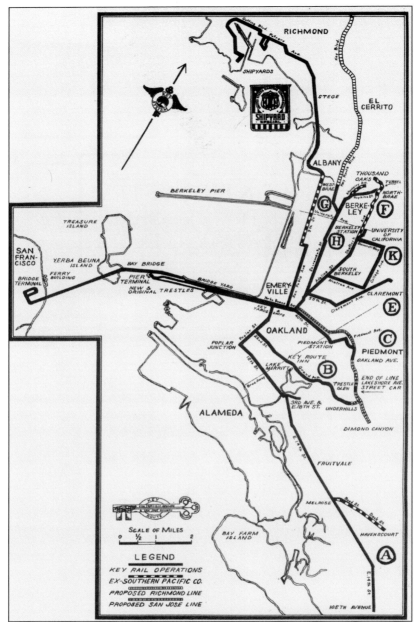

This map shows all Key Route transbay rail operations from 1903 to 1958, including Shipyard Railway and the proposed but never built San Jose and Richmond trackage. (Peralta and Associates.)

ON THE COVER: From the 1939 start of the Bridge Railway, the Key System and the San Francisco-Oakland Bay Bridge were linked both operationally and in the public's mind. A two-unit eastbound train is descending from the bridge's third-rail territory in March 1957. Soon the pantograph on lead Unit No. 130 and its mate will rise to get the necessary 600 volts of electricity from the overhead cable. (Photograph by Fred Matthews.)

IMAGES
of Rail

THE KEY SYSTEM
SAN FRANCISCO AND
THE EASTSHORE EMPIRE

Walter Rice and Emiliano Echeverria

ARCADIA
PUBLISHING

Published by Arcadia Publishing
Charleston, South Carolina

Printed in the United States of America

Library of Congress Catalog Card Number: 2006935610

For all general information contact Arcadia Publishing at:
Telephone 843-853-2070
Fax 843-853-0044
E-mail sales@arcadiapublishing.com
For customer service and orders:
Toll-Free 1-888-313-2665

Visit us on the Internet at www.arcadiapublishing.com

A Key System F-train awaits riders at its Solano Avenue, Thousand Oaks terminal before departing for San Francisco via the Bay Bridge in 1956. (Emiliano Echeverria collection.)

CONTENTS

ACKNOWLEDGMENTS

The process of writing this book dealing with Key System's San Francisco Eastshore Empire transbay services has provided the authors with both a new and renewed admiration toward the entrepreneurs who built and maintained the Key and those who chronicled it—both authors and photographers. It has brought back a flood of personal memories.

Two personalities are paramount in Key's transbay history—Francis Marion "Borax" Smith and Alfred J. Lundberg. The very existence of the Key Route was due to the entrepreneurial drive and energies of Smith; even though what was accomplished was only a partial realization of his grandiose dreams.

Alfred J. Lundberg guided successfully the Key System rail from its ferry days to that of the Bridge Railway, against the background of depression and war. Although Lundberg's primary purpose was to ensure Key's financial integrity, his skill at achieving this goal by largely focusing on productivity increases merits admiration.

Two historians—Vernon J. Sappers and Harre Demorro—have significantly enhanced the written history of the Key Route. Most will note that many of our photographs are credited to the Randolph Brant collection. Rudy's collection was bequeathed to coauthor Emiliano Echeverria; its possession was a major incentive for this volume. Noted authors Fred Matthews and John Kirchner have kindly granted permission to use their photography. Special "thanks" to John, who rode the Key units in both North and South America, for sharing his photography and knowledge about the rebuilding of the 31 Key units that went to Buenos Aires. Historians Paul Trimble and Mike Anderson shared their collections. Bart Nadeau, the archivist of the Western Railway Museum, provided access and use of the museum's collection and offered his own cogent insights. The contemporary cartoons are the direct result of the newspaper research efforts of San Francisco cable car gripman Val Lupiz. Don Holmgren, Joe Thompson, and Mitch Laird reviewed our materials and offered their much-appreciated suggestions. Of course, there are names that should receive credit, but their record of accomplishment has been lost. Our thanks and gratitude goes to all.

—Walter Rice, Ph.D.
San Luis Obispo, CA

—Emiliano Echeverria
Oakland, CA

INTRODUCTION

October 26, 1903, was both a remarkable and important milestone date in the history of San Francisco Bay Area transportation in general, and in particular for what was later known as the "Eastshore Empire." On that date, the first electric train of the San Francisco, Oakland, and San Jose Railway, with 250 dignitaries onboard a four-car train, departed from downtown Berkeley to the company's Oakland pier, where they boarded the ferry *Yerba Buena* for San Francisco. Although the new enterprise did not fulfill its original grandiose corporate title or its subsequent company name (1908), the San Francisco, Oakland & San Jose Consolidated Railway, the new company was destined to became a significant factor in the economic development of the San Francisco East Bay, notably the Eastshore Empire cities of Berkeley, Piedmont, and Oakland. San Jose was an elusive goal never obtained. The new company soon marketed its transbay operation as the Key Route.

Francis Marion Smith (also known as "Borax" Smith and the "Borax King") was the major entrepreneur behind the creation of this new transbay company. The demographics of San Francisco and the East Bay to Smith and other capitalists, such as Frank Havens, offered solid economic opportunities. Yes, San Francisco was growing. At the start of the 20th century, demographers estimated San Francisco could grow by as much as 145,000 people per decade. The East Bay had a maximum growth potential of 170,000 people per decade.

The inhibiting factor to San Francisco growth was the fact that much of the western half of the city, which was referred to by San Franciscans of the period as "The Great Sand Waste" or the "Outside Lands," had no or inadequate and circuitous public transit. The problem largely lay with Twin Peaks, mountains that blocked direct transit service from the city's commercial areas to much of western San Francisco.

Borax Smith and associates, therefore, reasoned that for a San Francisco office worker a well-run rapid transbay service that consisted of a ferry service and electric cars could make East Bay points time competitive compared with many San Francisco neighborhoods. As San Francisco's commercial working population expanded, many would thus be attracted to the East Bay because of time-competitive transit, lower housing costs, and "better" climate. It was no accident that one of Smith's ventures used the corporate title The Realty Estate Syndicate.

Data would prove Borax Smith right. By 1912, those working at or visiting San Francisco businesses would significantly enlarge its daytime population. According to Bion J. Arnold's *Report on the Improvement and Development of the Transportation Facilities of San Francisco* (March 1913), during 1912 the number of weekday transbay commuters equaled 23 percent of the city's residential population, or more than 168,000 transbay commuters. Many of these commuters were lured to the Eastshore Empire by the transbay service the Key Route offered.

Borax Smith's company, however, was "the second kid on the block." A predecessor to Southern Pacific Railroad's (SP) East Bay steam locals had started on September 2, 1863. By 1902, Southern Pacific was operating in excess of 500 daily East Bay steam locals.

Besides taking on an established rival, Borax Smith would be confronting an organization that was enjoying an era many regard as the railway's zenith of political power. Smith had monitored the successes and failures of Southern Pacific. The railroad's predatory tactics had created enemies, many of whom were powerful. He had witnessed the railroad vacate San Francisco's local traction market.

Electric streetcars using overhead wires had been running in San Francisco since April 1892. Although streetcars had begun to replace horsecar and cable car service, the opponents of the streetcar were successful in prohibiting overhead wires on major thoroughfares. The "powerful" railroad could not rid itself of obsolete cable car lines. In short, Smith's competitor was not as powerful as the public stereotype made it out to be.

Borax Smith's strategy to successfully confront Southern Pacific was ingenious—use electric trains instead of steam powered. Southern Pacific's urban steam locomotives were increasingly regarded as dirty, smoky, cinder throwers that impeded increases in property values.

Electric cars were faster, cleaner, and quieter than steam, and most importantly, they were less costly. The capital and operating cost of electric cars allowed lines to be pushed out to undeveloped areas—a real estate speculator's dream. Smith and associates had acquired more than 13,000 undeveloped acres in Oakland and Berkeley.

Smith was well aware that his greatest potential for significant passenger traffic, and therefore a profitable operation, came from getting riders to desert the SP local steam trains. His tactic was simple—provide a reliable, faster system than the entrenched Southern Pacific. Electric operation was but part of the equation to achieve this goal; central was the length of pier from the eastern shore into the bay. The longer the pier, the shorter the time to San Francisco, since more of the distance was covered by the faster electric train.

The former California and Nevada Railroad's Yerba Buena Avenue wharves formed the basis of the company's trestle into San Francisco Bay—a trestle that extended 3.26 miles to what is today Yerba Buena Island (then Goat Island)—at which point passengers would transfer to a ferry for the short ride to San Francisco. The water portion of the trip to San Francisco's Ferry Building was 2.85 miles. Southern Pacific's Oakland Mole passengers by contrast had a water journey of 3.5 miles.

Critical to the success of the new venture was access to San Francisco. Fortunately for Smith, the Ferry Building was owned by the State of California and not the Southern Pacific Railroad, who undoubtedly would not have allowed Smith's fleet to moor.

Smith's new Berkeley line was more than successful. Within a little over a month from inception, schedules had to be expanded from 41 daily trips to 97 in an effort to meet the crush of passengers. Why not? The citizens of Berkeley had a smooth, speedy ride with a travel time from the center of Berkeley, University Avenue, to the Ferry Building in only 35 minutes—all for a dime. The long-dominant Southern Pacific had a worthy rival.

Buoyed by this success, Smith turned to expanding his transbay rail network (details of these routes are found in chapter one). Competitor Southern Pacific was awakened by Key's competition, and SP, by the end of 1911, would convert its transbay lines to a high-capacity, modern, electric system. These conversions would place SP on equal, competitive footing with Key System.

Smith and his associates not being content with their East Bay rail empire, had expanded into water, light and power, and real estate on a grand scale. Soon the bubble would burst. Their debt-laden holding company collapsed in 1913. Smith was bankrupt.

The Key Route would be in receivership until June 1, 1923, when a new operating company took over—the Key System Transit Company. There, however, was a basic fundamental structural problem with the Eastshore Empire's transbay service. The combined effect of the Key and Southern Pacific lines saturated Oakland and Berkeley with too much transbay transit. Each company's market share was too small to be economically viable.

After the collapse of the U.S. economy in 1929, the situation worsened. The rational solution, outside of a merger, was for SP and Key to eliminate duplicate lines, thereby granting one company in each territory a geographic monopoly. This was done in March 1933. However, even

the end of direct competition and the opening of the Bridge Railway in January 1939 could not forestall Southern Pacific's abandonment of its Eastshore Empire electric trains because of great financial losses. Nearly 78 years of Southern Pacific transbay service came to an end on the eve of America's entrance into World War II in 1941. Key System filled the void by extending some of their transbay rail lines and expanding its transbay motor coach service. Key System was left alone to shoulder the huge increase in riders the war caused.

Since 1935, the company's name had been Key System. That changed for the last time in 1946 to Key System Transit Lines after National City Lines (NCL) purchased controlling interest. After experiencing the sharp postwar drop of ridership, rising costs, significant labor problems, and a deteriorating physical rail plant, NCL substituted motor coaches on the bridge rail lines on April 20, 1958.

Key System itself went out of business on October 1, 1960, when it was acquired by the Alameda-Contra Costa Transit District (AC Transit). Voters had approved the creation of the AC Transit in 1956 and authorized funding in 1959.

It's now time to go back and enjoy the era when the Eastshore Empire was built and served by Key System's transbay service.

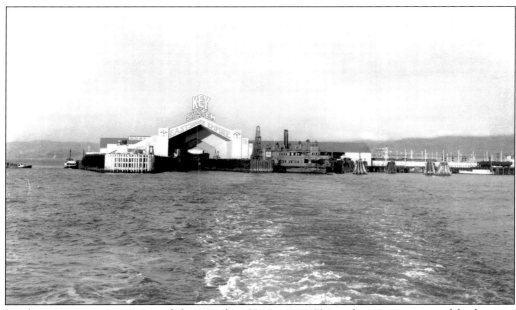

Marketing was not a victim of the pier fire. Key's new 1934 replacement terminal had a very large illuminated sign on top of the single passenger ferry slip that spelled out "Key System" for Southern Pacific and the entire world to see. On the ferry slip itself were spelled out the words "Eastshore Empire." From this promotional piece, the name of this book was derived. (Sappers collection, BAERA Archives 21920.)

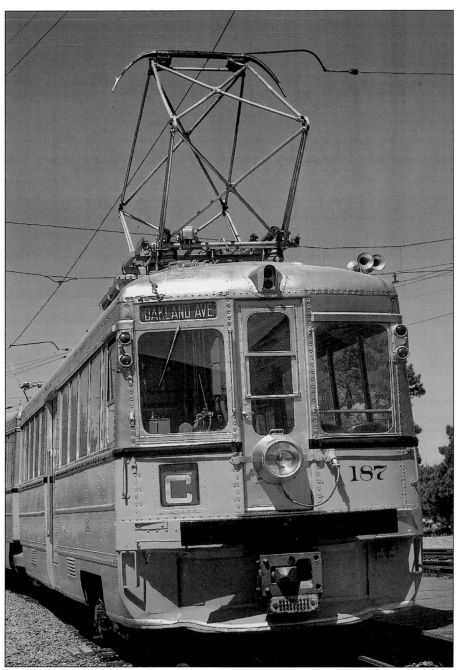

Although it has been nearly a half-century since Eastshore Empire citizens piled onto Key trains, today at the Western Railway Museum people can still experience a ride on a Key System bridge unit. At the museum, unit Nos. 182 and 187 are still boarding passengers. No. 187 has been restored back to its original orange and silver colors. Even though it has been 80 years since the bridge units made their public debut, their classic exterior design renders them contemporary in the 21st century. (Walter Rice photograph.)

One

CREATING KEY'S EASTSHORE EMPIRE TRANSBAY LINES

Electricity easily triumphed over obsolete steam. Borax Smith's Berkeley line, as noted earlier, was wildly successful. Ridership boomed. The original fleet of 16 cars was soon incapable of meeting demand. The open lands adjacent to Adeline Street were rapidly subdivided, and real estate speculators were both delighted and encouraged.

Before the inauguration of the Berkeley line, regional expansions had been planned. On June 1, 1904, a crowd even more enthusiastic than that for the first Berkeley train hailed the opening of the company's second line—the Fortieth Street–Piedmont line—when the ceremonial first train entered the new line's terminal, the Piedmont Station. In 1912, Alcatraz and College Avenues were made part of Key's transbay system, connecting with Berkeley line trains.

On November 21, 1924, the Piedmont line was extended for the first time into Piedmont to Oakland Avenue using part of the private right-of-way of the never-built San Jose line. By the 1930s, except for rush-hour service when a single car was uncoupled from a multiple-car pier train to service east of Piedmont Station, all Oakland Avenue service was provided by a connecting single-car shuttle from Piedmont Station.

The prize still awaited—populous central Oakland. On May 16, 1906, the Twenty-second Street line (now West Grand Avenue and Grand Avenue) opened. Fifty-fifth Street and Claremont Avenue shuttles began in 1906, with pier trains in 1910.

Downtown Oakland proved to be a difficult destination for Key to achieve. This was Southern Pacific territory, and the city fathers were influenced by the railroad. It was not until August 15, 1915, that service was permanently established between the pier and the downtown terminal of Twelfth Street and Broadway. A series of shuttle services that connected with the Twenty-second Street line at Poplar Junction had started on June 9, 1909.

The last transbay line was also the company's weakest. This was the Northbrae or Sacramento Street line that opened from the pier on November 11, 1911. Associated with this line was the Westbrae or Albany Branch.

The Key System's Eastshore Empire Transbay service was now effectively completed. In the future, there would be extensions, curtailments, and finally total abandonment of the Eastshore Empire's Key rail network.

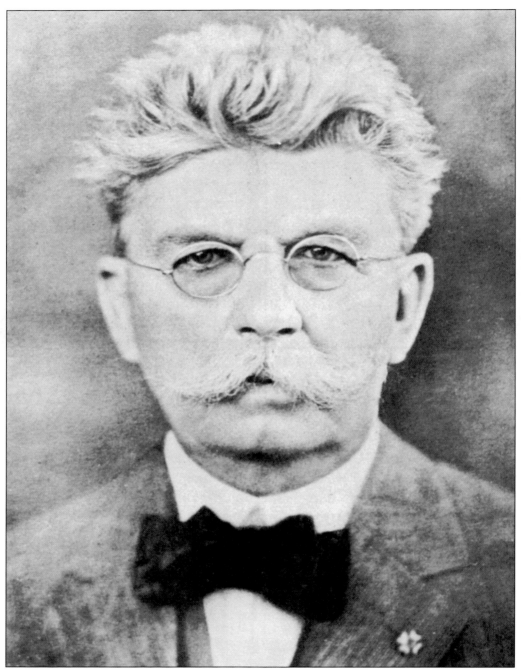

The Eastshore Empire's economic development received a quantum leap forward when the wealthy Francis Marion "Borax" Smith moved to Oakland in the 1880s. With Smith came the vision of a vast freight, passenger, public utilities, and real estate empire centered in the East Bay. The Key Route was a partial realization of the grandiose dreams of Borax Smith. (Emiliano Echeverria collection.)

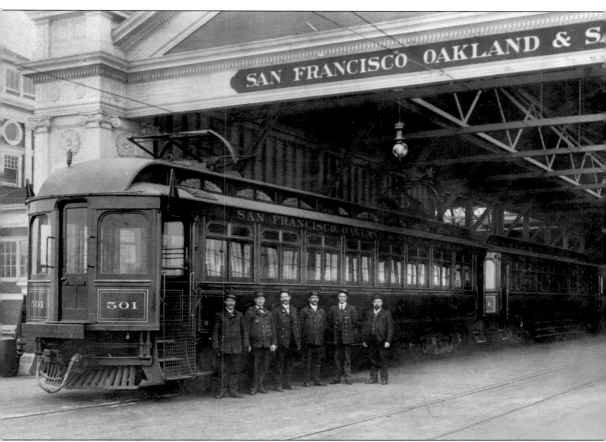

It is the very first day of service, October 26, 1903, and the first official ceremonial train has come and gone. The crew of the next regular scheduled train to Berkeley is proudly posing beside one of the company's handsome new 500 Class interurban cars. However, a single line, regardless of its success, could not fiscally justify Smith's capital investment in the 3.26-mile trestle into San Francisco Bay, the pier terminal, and ferryboats. Additional ridership was required, which most economically could be secured by expansion in the Eastshore Empire. (Randolph Brant collection.)

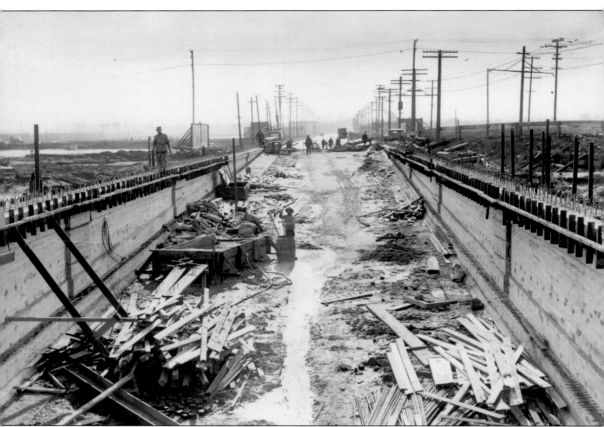

In order to reach San Francisco Bay, the tracks of the San Francisco, Oakland & San Jose Railway had to cross the heavily used mainline of the Southern Pacific Railroad. A crossing at grade would be an operational nightmare and very dangerous. The solution was a subway, built and paid for by Borax Smith. Subway construction is well under way in 1902–1903. (Randolph Brant collection.)

Soon after the 1904 opening of the Fortieth Street–Piedmont line, the city of Oakland forced compliance of the Fortieth Street franchise, requiring local streetcar service. Only streetcars offered free transfers to other streetcar lines. Citizens argued, and the City of Oakland concurred, that they could be forced to pay two fares for a local journey. Initial replacements were California-type cars—two open ends with an enclosed center section. Here No. 45 shows off the mandatory pantograph for Fortieth Street. It was required because the overhead contact wire was built with a tension designed for pantographs. (Randolph Brant collection.)

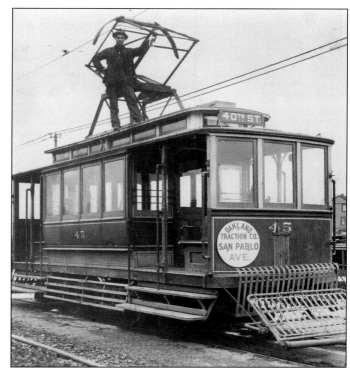

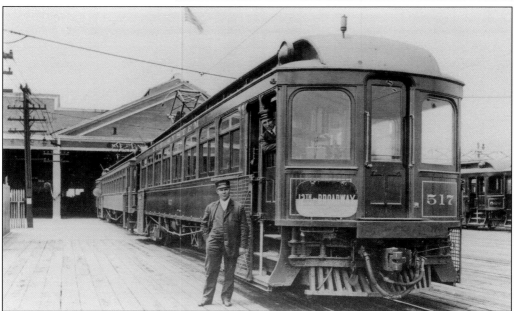

The crew of No. 517 is being posed by a professional photographer, who will return later to sell pictures. With the arrival of the next San Francisco ferry, the crew will soon be working. Before arriving from St. Louis Car Company, the 500s were awarded a design prize at the 1904 Louisiana Purchase Exposition. This was announced to all by a bronze plaque Key proudly placed on the side of No. 517. (Randolph Brant collection.)

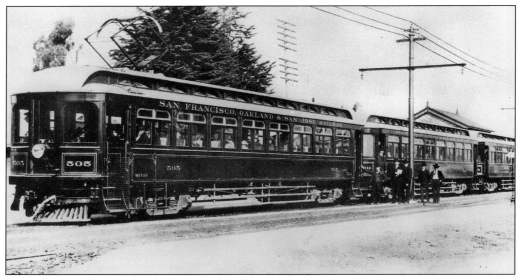

It is easy to see why the handsome wooden 500 Class electric interurbans of the San Francisco, Oakland & San Jose Railway rapidly attracted the majority of Berkeley's traffic away from the obsolete steam trains of their rival, Southern Pacific. The 500s were clearly built for high-speed service. Instead they spent their life on short, suburban, Eastshore Empire treks. A four-car, pier-bound train, led by motor No. 505, has stopped at San Pablo and Yerba Buena Avenues on the first day of service on October 26, 1903. (Randolph Brant collection.)

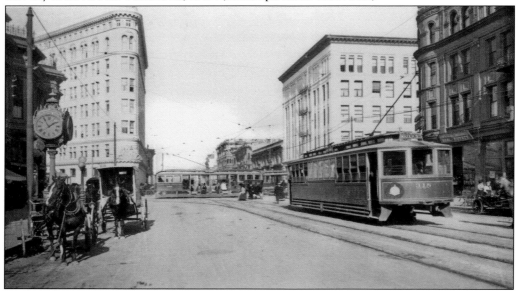

Borax Smith also owned an East Bay local streetcar system. There were, however, no free transfer privileges between Smith's Key Route and his streetcar companies. In order to be competitive with rival Southern Pacific, the Alcatraz and College Avenues line in South Berkeley was formally made part of Key's transbay system in 1912, thereby allowing free transbay transfers without jeopardizing the company's system-wide policy of no local transfers accepted. At the center of Oakland, Fourteenth and Broadway, Smith's streetcars lent a big-city flavor to the largest city in the East Bay, pictured here in 1910. (Randolph Brant collection.)

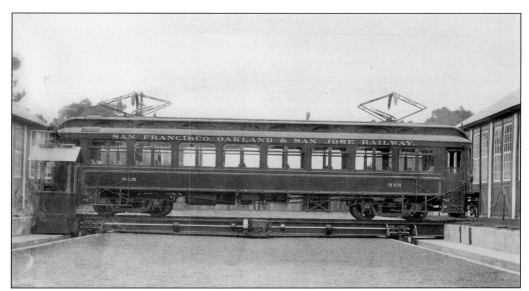

Car No. 515, part of the original group of 16 cars acquired by the San Francisco, Oakland & San Jose Railway, is on the Emeryville Shop transfer table in 1906. Car Nos. 511–516 were purchased as noncontrol trailers but were converted to two-motor cars. Uniquely, Car No. 515 has two pantographs but will soon lose one. (Randolph Brant collection.)

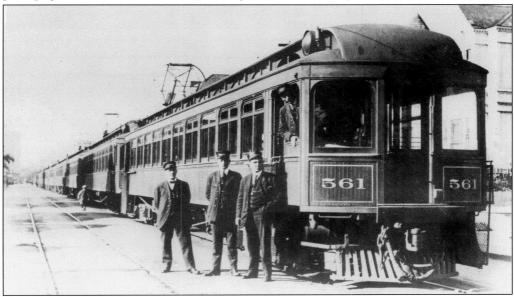

One of the most important junctions on the Key Route System was Forty-third and Linden. Here the important Berkeley line separated from the Claremont and Northbrae lines. Beginning in 1906, a series of shuttles began on Fifty-fifth Street and Claremont Avenue. The Fifty-fifth Street–Claremont Avenue line became a reality on May 10, 1910, when through service was established from the pier to the Claremont Hotel. The Northbrae line opened in November 1911. In order to minimize the number of pier train movements, westbound local and express trains were consolidated here. Eastbound trains were separated. Off-peak cars were stored on one of the four tracks, as illustrated in this posed 1907 view. (Randolph Brant collection.)

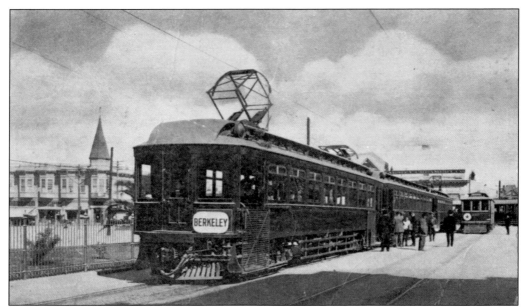

With Motor No. 530 at the head end, a three-car train is loading passengers at the Shattuck Square Berkeley terminus—Shattuck and University—in 1909. Fifteen minutes later, those boarding will be at the pier, and 20 minutes after that they will be arriving at San Francisco's Ferry Building. (Randolph Brant collection.)

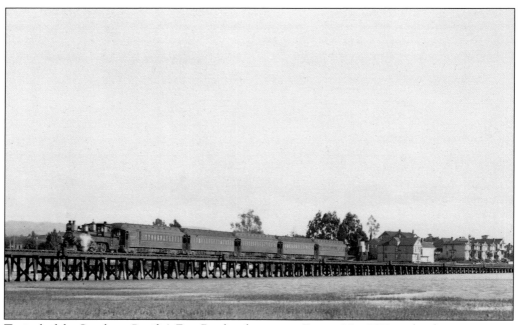

Typical of the Southern Pacific's East Bay local steamers, Engine No. 1501, with a five-car consist, is steaming across an inlet of Lake Merritt in the 1890s. Significant urbanization has yet to come to Lake Merritt. Soon passengers on Engine No. 1501 will be transferring to a ferry at the railroad's Oakland Mole for their trip across San Francisco Bay. (Randolph Brant collection.)

Pictured here in 1907, this Berkeley local soon will be stopping at its namesake city. Note that Engine No. 2142, the power for this local, is running backwards. It was standard practice to have engines reverse the train's direction by running around their cars, then back up a short distance to couple to the train. The expense of building and maintaining turntables was thus spared. (Emiliano Echeverria collection.)

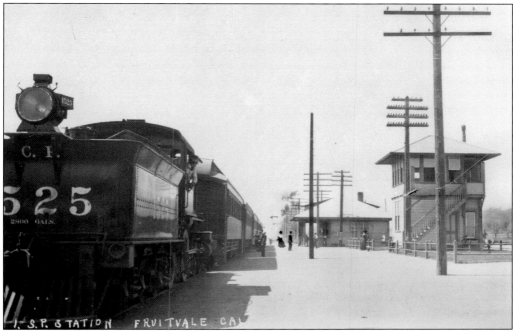

The engineer of No. 1535 is waiting for the highball to depart the East Bay local from the Fruitvale station in 1907. Although it had been 22 years since Southern Pacific had leased the Central Pacific, No. 1535 is still clearly marked "CP." Of course, the ownership and management of the two railroads was the same. Many of the 1911 replacement electric cars would carry on this tradition with the letters "CP" next to their numbers. (Emiliano Echeverria collection.)

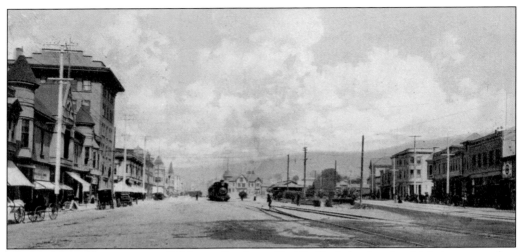

Arriving from Berryman in 1904 is a Southern Pacific Berkeley local, which has paused at Berkeley's University Avenue station before starting for the Oakland Mole. To the right of the photograph are the poles, wires, and tracks of the Key Route's Berkeley line. The two companies at this time were fierce competitors, but Key's passengers will have a faster trip to San Francisco. (Emiliano Echeverria collection.)

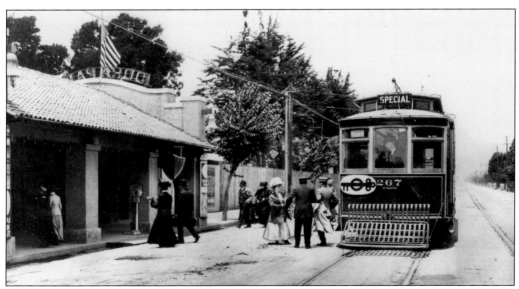

One of the many inducements that Borax Smith provided was Idora Park, an early amusement park located on Fortieth Street near Telegraph Avenue. Ex-Lehigh Railway Car No. 267 stops at the park entrance in shuttle service. The Lehigh cars were very substantial and saw service on the Key for over three decades. (Walter Rice collection.)

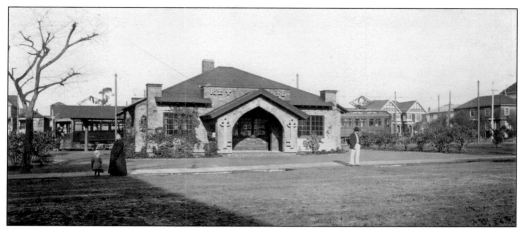

Borax Smith instructed his architect to leave no doubt that the wooden, rustic Piedmont station was a Key Route depot. Smith was successful. Pictured here around 1910, this first Piedmont depot, like its successors, was not actually in Piedmont but inside the city line in Oakland. The Piedmont route branched off the Berkeley line at Adeline Street onto Yerba Buena Avenue and continued eastward on Fortieth Street, where at Broadway a cut was constructed to Howe Street, just beyond which the Piedmont Station was built at Forty-first Street and Piedmont Avenue. The distance from the pier was 5.3 miles. (Emiliano Echeverria collection.)

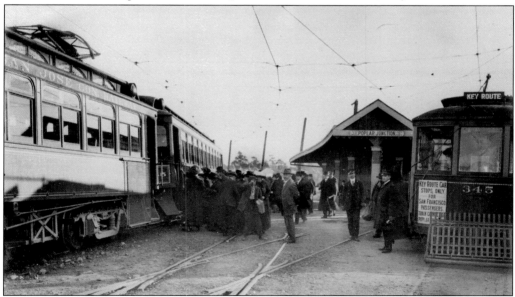

Downtown Oakland proved to be a difficult destination for Key to achieve. This was Southern Pacific territory, and the city fathers were influenced by the railroad. On August 15, 1915, permanent through-pier service was established. The through routing followed the Twenty-second Street line from the pier to Poplar and Twenty-second Streets, then continued on Poplar to Twelfth Streets, where it turned eastward until it reached Broadway. In 1917, the line was extended to Third Avenue and Eighteenth Street (Central Car House). Before August 1915, Twelfth Street line passengers rode a shuttle "Only for San Francisco Passengers," which connected with the Twenty-second Street line at Poplar Junction. Shortly before the start of direct pier service, San Francisco–bound riders are making this transfer. (Randolph Brant collection.)

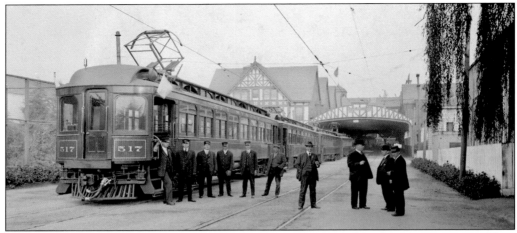

Brass hats have gathered at the rear of the Key Route Inn for a long-forgotten occasion. Note the expensive Havana cigars, something few motormen or conductors could afford. (Randolph Brant collection.)

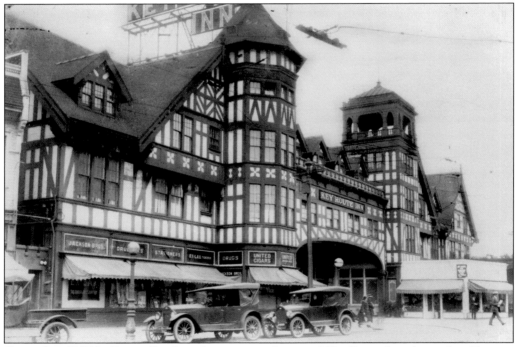

Opened in 1907 by Borax Smith and associates, the grand Key Route Inn, located at Twenty-second Street (now Grand Avenue) and Broadway, was for many years Oakland's finest hotel. The Key Route Inn was served by the Twenty-second Street line, which opened on May 16, 1906. This line branched off the land-pier trackage at Poplar Street, ran on Poplar to Twenty-second Street, and then went eastward on that street to Broadway Terrace, a distance of six miles. In January 1925, the Twenty-second Street line was extended eastward to Underhills through the inn to serve the upscale Trestle Glenn neighborhood. In 1920, the date of this photograph, the extension was five years away. Like so many grand hotels, fire destroyed the Key Route Inn in the 1930s. (Randolph Brant collection.)

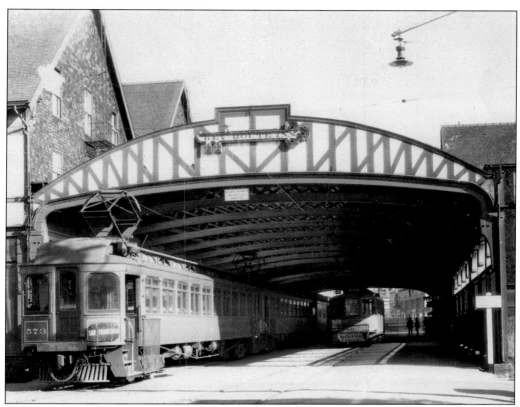

Typical of many grandiose structures, the back of the building was not as imposing as the front, and Key Route Inn was no exception. Every 20 minutes, 500 Class trains would leave the center of the Key Route Inn bound for the pier. The streetcar next to No. 573 and its mates is a connecting shuttle to Underhills. (Randolph Brant collection.)

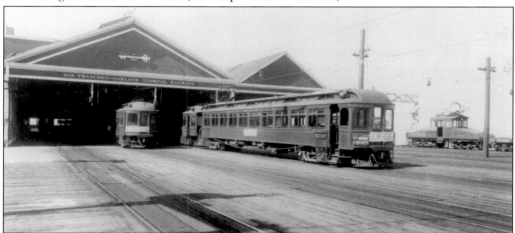

A bitter strike between the Carmen's Union and the Key Route resulted in the defeat of the strikers, and it would be decades before organized labor would be a factor. Pictured here in 1919, cars at the Key pier display signs that they are being operated under court order. The Key had resorted to the time-honored method of a court injunction to break the strike. (Paul Trimble collection.)

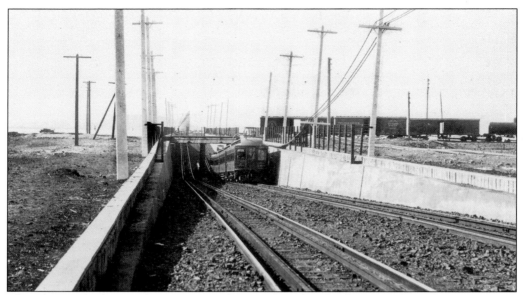

The subway, which carried Key trains to the pier, dipped under the SP tracks and allowed for the heavy traffic of both lines to pass in safety. After the rails were removed in the early 1960s, the subway became part of the access road to the sanitation plant built adjoining the site of the old Bridge Yards, a function it serves to this day. (Randolph Brant collection.)

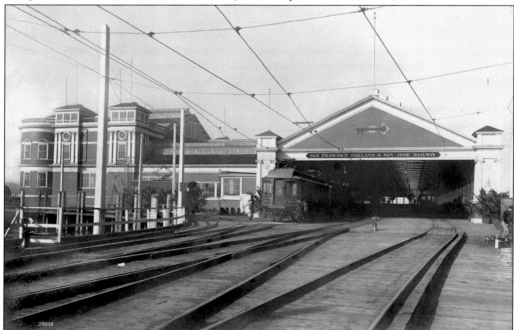

Opening day at the pier has a Berkeley train waiting to depart with a load of passengers anxious to see if Borax Smith really was out to seriously compete with the "Octopus." As pictured here, the pier only had three tracks, which ultimately increased to nine, to handle the ever-increasing traffic. Smith did indeed mean business, but it would come at a price. (Sappers collection, BAERA Archives 28948.)

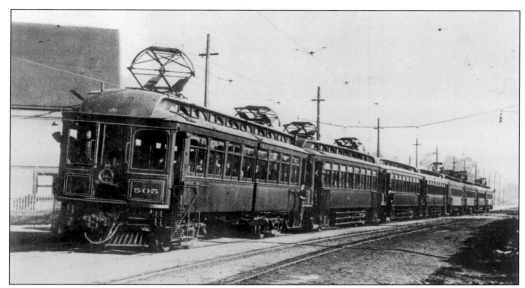

The first Key Route train to Berkeley is ready to begin an Eastshore Empire tradition that would last almost 55 years. Beautiful, elegant, clean trains greeted the commuter, a contrast to the dingy, sooty Southern Pacific steam locals. Unlike the successful Berkeley line, the 1911 Sacramento Street or Northbrae line was consistently weak. This route departed from the Berkeley line at Adeline and Fifty-fourth Streets, shifted to Lowell Street, then from Sacramento Street to Rose Street, at which point it curved into Hopkins, terminating at Northbrae. At Sacramento and University Avenue, connections were made with the Westbrae or Albany line that wandered through open territory for approximately a mile before ending at Westbrae. (AC Transit collection.)

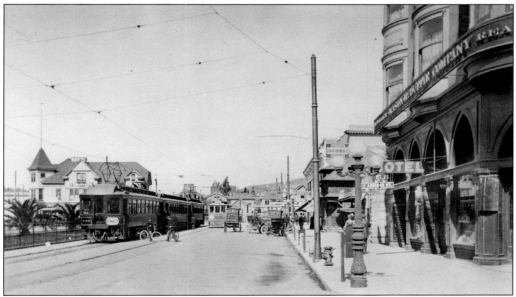

Looking north, to the left, are the gardens of SP's Berkeley Depot. Straight ahead is University Avenue; a block to the right, out of the photograph, is the University of California Berkeley campus. Downtown Berkeley would be a battleground between the Key and the SP for three decades. (Randolph Brant collection.)

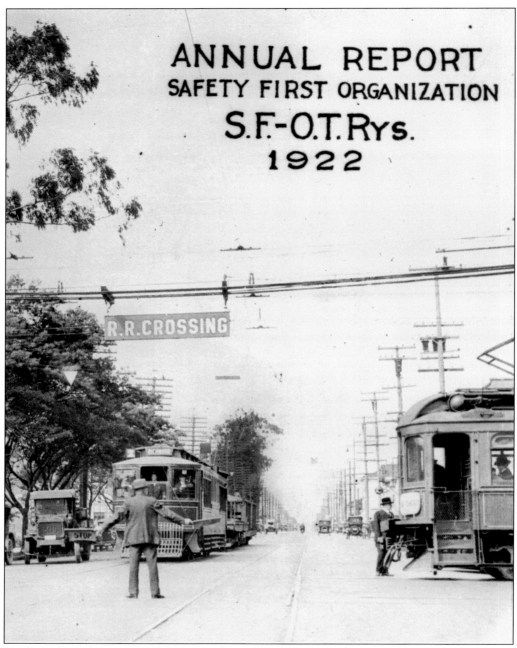

ANNUAL REPORT
SAFETY FIRST ORGANIZATION
S.F.-O.T.Rys.
1922

R.R.CROSSING

Key Route's 1922 Annual Safety Report featured a flagman trying to safely clear Key Route cars past heavy streetcar and automobile traffic. This dangerous job constantly subjected the employee to the possibility of being struck by an errant motorist. Later automatic traffic signals would replace the picturesque flagmen. (Randolph Brant collection.)

Two

The Cars Key's Eastshore Empire Patrons Rode

The company's first 16 cars that opened the Berkeley line reflected the line's destiny as management, notably Borax Smith, defined it. These cars were clearly built for high-speed service to San Jose, not a suburban trek to Berkeley.

The first 16 cars, products of the St. Louis Car Company, were numbered 501–516. Ultimately, there were 91 cars in the 500 Class, representing four subgroups. All Key transbay cars, from the very first 500 in 1903 to the last articulated 1938 bridge unit, had General Electric Sprague-type M controls and C6-J master controllers. Thus any car, regardless of its vintage, could run with any other transbay equipment type.

The unplanned-for high levels of Berkeley line ridership resulted in the Key Route soon placing a new order with St. Louis Car Company for 24 cars, Nos. 517–540. In addition, the company's very complete Emeryville Shops built 10 trailers, Nos. 541–550. In 1909, these shops built 16 more trailers, which were assigned the numbers 551–566. Unlike the former 500s, these cars were about 11.5 feet longer, having a length of nearly 70 feet. These were called "The Big 500s."

As long as the company was under the control of Borax Smith, management would not abandon the San Jose dream. The last group of 500s, Nos. 567–591, were built by the St. Louis Car Company in 1911–1912, when Smith felt outside financing for the San Jose extension would become a reality. With Smith's forced 1913 departure, further construction of the 500s went also.

While waiting for the delivery of car Nos. 517–540, Borax Smith acquired 18 unwanted Lehigh Valley Traction Company cars. One Lehigh, No. 271, exists today in its streetcar configuration at the Western Railway Museum in Rio Vista Junction, California. The purchase of this car, from Key in 1946, resulted in the creation of the Bay Area Electric Railroad Association, the operator of the Western Railway Museum.

During the prolonged Fortieth Street franchise dispute, riders were treated to a variety of conveyances on both the Fortieth Street shuttle and the Westbrae shuttle. Early passengers boarded single-truck, California-type cars (open end sections with longitudinal seating and an enclosed center section). After 1912, passengers loaded on to rebuilt former Eastshore and Suburban double-truck cars that sported the five-window ends characteristic of the Los Angeles's Huntington Standard cars. The Alcatraz Avenue riders enjoyed upgraded, lightweight, city streetcars from the 350 Class.

Key profited by its 500 Class design errors. In 1917, the company introduced its low floor, center entrance, 650 Class transbay cars. The continued financial struggle that Key System faced curbed additional 650s from being added to the roster. Also, as time progressed, the Bridge Railway directly into San Francisco became more likely.

The 650s' design proved to be so successful that it became the prototype for the next and last generation of Key transbay equipment—the articulated bridge units of the 1930s. Parts from the 650 Class would live on in some of these units (the story of these cars are found in chapter four).

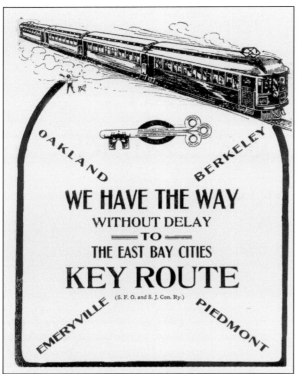

"We Have the Way Without Delay" ad featured the Key Route's handsome 500s at speed and was Key's not-so-subtle message implying that no one would want to ride Southern Pacific's slow, dirty, smoky, cinder-thrower steam lines. Proponents of good marketing copy would be pleased that the advertisement reinforces the Key Route brand by prominently featuring the company's stylized map in the form of an old-fashioned key. (Val Lupiz collection.)

In 1904, Borax Smith's Oakland Traction purchased 18 Lehigh Valley Traction Company cars that in their early years saw service on the Key Division. Lehigh No. 257, still in streetcar configuration, is posed with its crew and perhaps a couple of passengers in front of Smith's estate at Fourth Avenue and East Twenty-eighth Street. (Randolph Brant collection.)

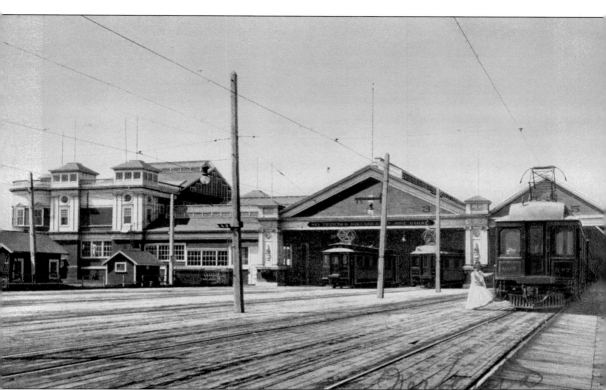

Soon another ferryboat from San Francisco would arrive, and the single lady boarding a set of 500s would be lost in the scores of passengers. The 500s conveyed their importance by their close resemblance to the latest steam railroad passenger coach design. This proved to be a design flaw. Narrow doors, three-step outside entrances, and tiny vestibules appropriate for steam lines were an operation hindrance when large crowds needed to disembark or board rapidly. Later-built 500s subsequently would be modified with double-wide entrances. On the far left is a train set headed by one of the 18 ex-Lehigh Valley Traction Company cars. (Bert Ward collection.)

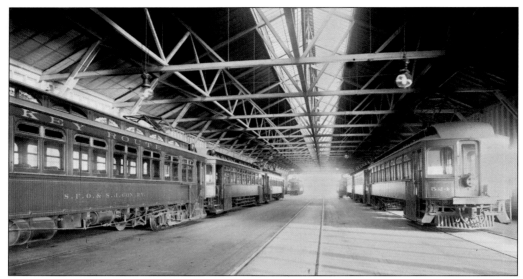

The financial weakness of Borax Smith's empire is not apparent in the Key Route's handsome 500s and the company's immaculate, maintained pier train shed, pictured here in 1909. One financial concession, however, was the reorganization of the company during 1908, becoming the San Francisco, Oakland & San Jose Consolidated Railway. The 500s are lettered below the windows with "S.F.O. & S.J. Con. Ry.," reflecting this change. But the 500s' letter boards proudly display "Key Route," the name everyone called Borax Smith's transbay company. (Sappers Collection, BAERA Archives 17717.)

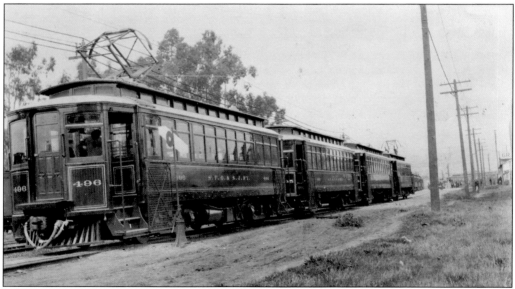

While waiting for the delivery of cars, numbered 517–540, from the St. Louis Car Company, Borax Smith acquired 18 unwanted Lehigh Valley Traction Company cars. In 1906, 12 of these cars were rebuilt for Key Division service. The rebuilding entailed pantographs, end-train doors, entrance gates, buffer plates, pilots, St. Louis trucks and whistles, and multiple-unit electrical equipment for transbay service. Motor Car No. 496 with two trailers and a second motor are pictured resting at the Yerba Buena Yard in this configuration in 1910. (Randolph Brant collection.)

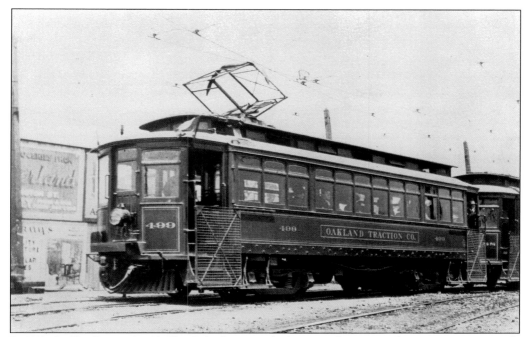

In 1911, the Key Division's 490 Class Lehighs were rebuilt a second time; a trailer was semipermanently married to a motor creating a two-unit car. Lettering was changed from "S. F. O. & S. J. Con. Ry." to "Oakland Traction Company" in a crude ruse to convince the city fathers of Oakland that these cars met the "streetcar" requirement of the Twelfth Street ordinance. It failed. In this 1911 view, No. 499 is trailing No. 488 in Pier–Twelfth Street service at Poplar Junction. (Randolph Brant collection.)

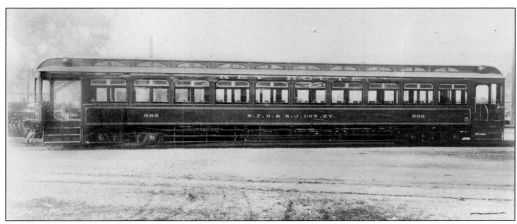

Starting with construction of No. 551 in 1909, the length of all newly constructed 500s increased to from 58.5 feet to almost 70 feet. The gargantuan size earned the name "Apartment House Fives" for the cars numbered 551 to 591. Car No. 566 poses here in 1909 for it builder's photograph on the Emeryville Shop's transfer table. (Randolph Brant collection.)

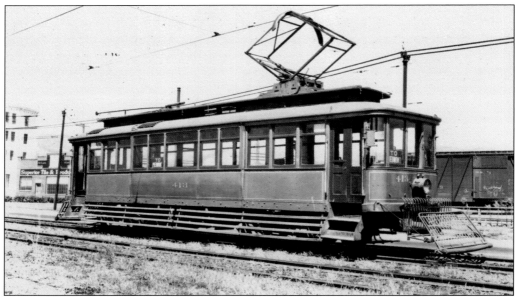

In 1912, following Borax Smith's acquisition of the Richmond area's Eastshore & Suburban Railway, three of that company's former cars were allocated to the Key Division. After each received a Brown Diamond pantograph and air whistles, they were assigned to the Westbrae and the Fortieth Street-Piedmont shuttles. These cars had as their prominent design feature five-window ends, characteristic of Los Angeles's Huntington Standard cars. Here Car No. 413 is signed for Piedmont. (Randolph Brant collection.)

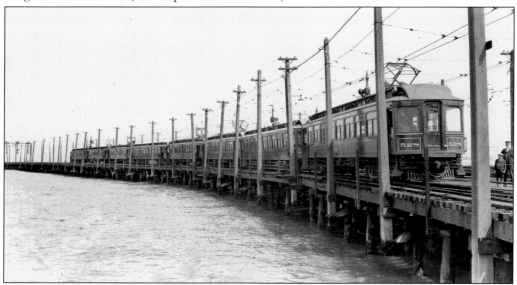

Led by No. 528, eight 500s are deadheading to the pier to pick up afternoon rush-hour Eastshore Empire residents. Although handsome in lines, the 500s did not offer any innovative technological changes, with one exception—the Brown Diamond roller pantograph. This invention substituted for the trolley pole. Its three-dimensional, diamond-shaped frame provided a multiple-inch roller contact with the overhead electric power cable. It assured that a train would not lose its overhead power and allowed it to rapidly reverse direction. (Randolph Brant collection.)

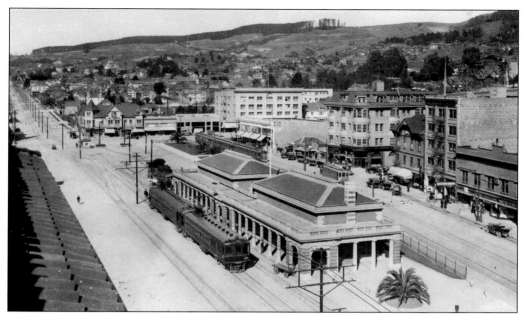

A clear demonstration of the intensity of competition between SP and the Key was the facilities of both companies in downtown Berkeley. Here Key and SP are head-to-head in what would be a 20-year battle. In 1911, Southern Pacific countered Key with the first modern rapid-transit system on the West Coast, characterized by the heavy construction seen in such lines in the East. (Randolph Brant collection.)

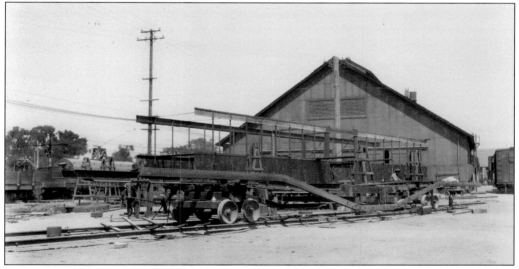

Key System introduced its fast-loading center door 650 Class in 1917. This design, featuring low-floor trucks and lightweight traction motors with two inside steps (compared with the three outside steps of the 500s) and wide center doors, allowed the 650s to off-load and board passengers rapidly. Ultimately, the company acquired 38 of this design, Nos. 650–688. Management regarded the 650s as an "excellent" car. The last subgroup of this series, Nos. 677–688, was built by Key at its Emeryville Shops in 1925. Pictured here is the frame of one of these future cars. (Randolph Brant collection.)

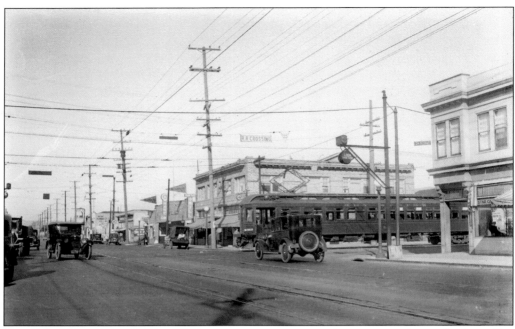

The wigwag signals—automatic flagmen– are warning motorists to stop or be crushed as a Key Pier–bound Claremont train crosses on Fifty-fifth Street at Grove Street (now Martin Luther King) and its local streetcar trackage in October 1921. It would be no contest between a Key System 500 and one of Mr. Ford's "Tin Lizzies," or any other motor vehicle of the period. (Randolph Brant collection.)

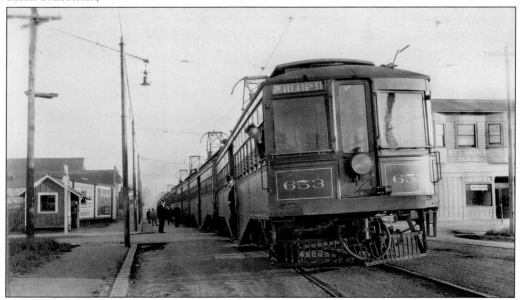

The city of Oakland felt the 500 Class car trains were too big to run through central Oakland. Accordingly, the Twelfth Street line became a mainstay of the 650 Class. Ironically, though, here is a six-car set of 650s at First Avenue and East Fourteenth Street enjoying much of Oakland's street space in the mid-1920s. (Randolph Brant collection.)

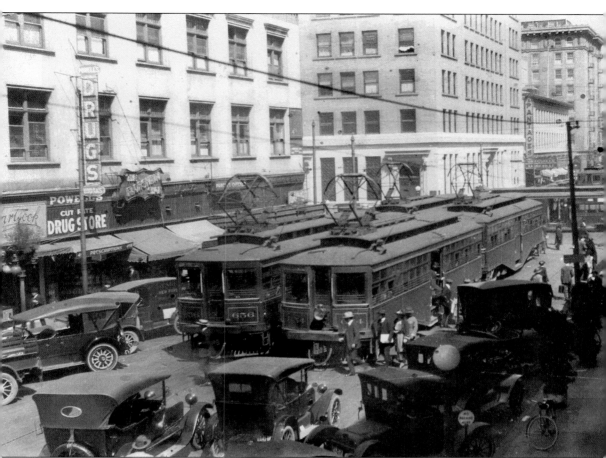

The prosperity of the Roaring Twenties is very noticeable at downtown Oakland's Twelfth and Oak Streets. People, autos, and two sets of Twelfth Street 650 Class cars are all vying for the limited space. Central Oakland was a retail and commercial magnet, thanks largely to the traction investments of Borax Smith. (Randolph Brant collection.)

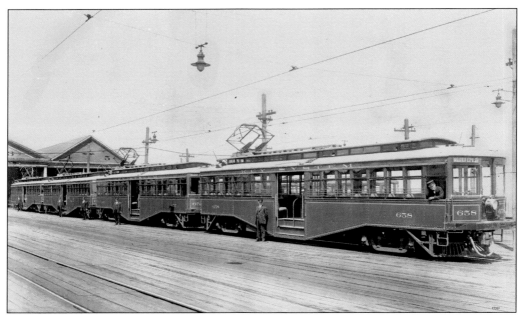

During the 1920s, four handsome 650s, with a posed crew of two motormen and four conductors, await the surge of passengers with the next arrival of a San Francisco ferry. All cars will serve the Twenty-second Street line; at Poplar Junction, No. 658 and No. 657 will run express to Broadway, and the last two cars will service the local stops. (Sappers Collection, BAERA Archives 15363.)

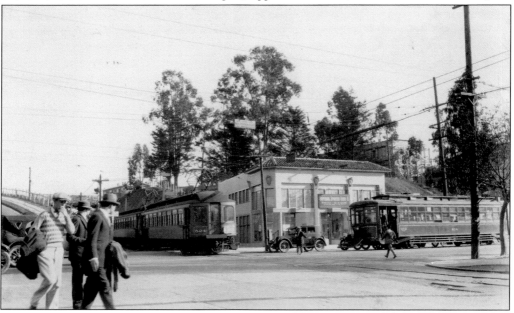

In this classic 1922 panorama, No. 524 is heading out and another 500 is emerging from the single-track cut at Fortieth and Broadway, located immediately west of the Piedmont Station. On the No. 6 line, Key-built streetcar No. 814, pictured in its original configuration with a clerestory roof, is halted by an unusually garbed street guard—a gentleman wearing a business suit. (Randolph Brant collection.)

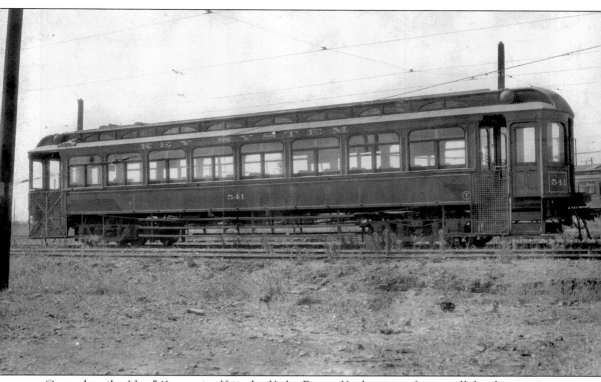

Control trailer No. 541 suns itself in the Yerba Buena Yard waiting for its call for the evening rush-hour service. They were longer than the original 16 500 Class cars, whose platforms proved to be too short. Built in 1908, No. 541 was among the first of the 500-type cars to be scrapped in 1937. (Randolph Brant collection.)

A word of APPRECIATION

THIRTEEN letters all told have been received by Key System in response to our advertisement asking for suggestions and criticisms.

Most of the suggestions made were valuable. These are being considered in connection with the Seven Million Dollar development program detailed in the current issue of Key System News, now in all racks on our trains and ferryboats. We are grateful for the suggestions themselves and for the helpful spirit that prompted them.

We also are grateful for the fair and interested attitude of the public during the recent Railroad Commission hearing in Oakland. Salient facts of this hearing, reported more fully in Key System News, include the following:

1—This company is not now earning enough money to keep up the service it is now rendering.

2—No additional revenue has come from an investment of nearly $3,000,000 in Eastbay service and more than $2,500,000 in transbay service since 1920.

3—A rate readjustment will provide a proper return upon the value of our property and enable us to continue the development of the present transportation service to keep pace with the growth of our Eastbay communities. We know the new rates of fare will compare more than favorably with similar rates throughout the country.

Read the large report of the hearing, in Key System News. It will interest you. We will gladly mail a copy on request.

KEY SYSTEM TRANSIT COMPANY

C. O. G. MILLER.
President

The Key Route's public relations department had been hard at work designing this tactic, which put a positive face on what many in the 1920s would view as "robber barons" in action—namely, justification for a fare increase. The choice as presented was binomial—increase fares to ensure adequate service or let the infrastructure of Key's service crumble. (Emiliano Echeverria collection.)

During the late 1920s, the Key System adopted the Tomlinson type of coupling, which allowed for a rapid joining and separation of cars. This was important since consolidation and breakup of pier trains had to be done safely and rapidly within the confines of ever-decreasing headways. Car No. 678 is in the Emeryville Shops modeling the new device. (Randolph Brant collection.)

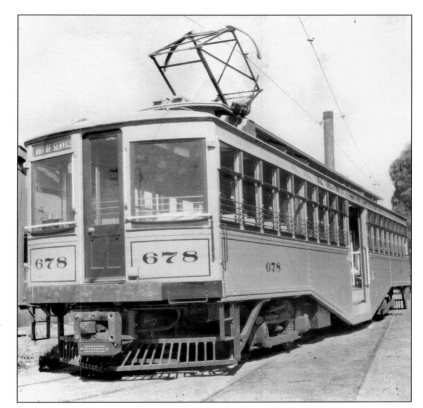

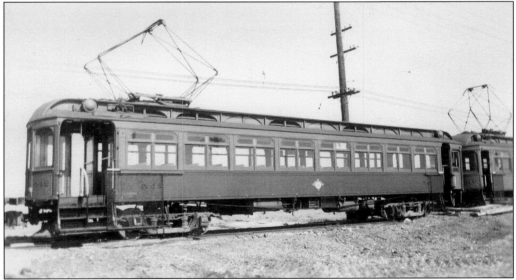

Twenty-eight years after its 1904 arrival, No. 541 rests in the Yerba Buena Yards showing off its orange paint. Only one end has a double-flow entrance, and note the high steps, hardly the design best for boarding and de-boarding large numbers of short-haul suburban passengers. Key System's Brown Diamond roller pantograph has been replaced with a standard-design pantograph. (Randolph Brant collection.)

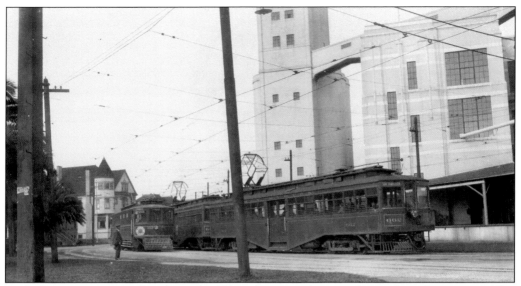

Poplar Junction continued in the early 1920s to be a transfer point for pier-bound passengers. The designation "K" was used for service to far away Mills College via East Fourteenth Street and Forty-sixth Avenue (High Street). Later the "K" designation would be used for the Alcatraz and College Avenues shuttle and "J" would be used for the East Fourteenth Street shuttle. (Randolph Brant collection.)

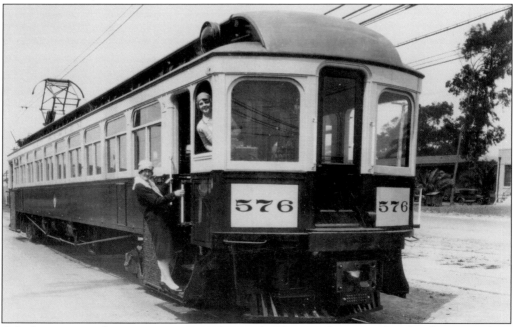

A little orange and cream paint can make nearly 16 years of steam railroad-style cars, such as "Apartment House Five" No. 576, look modern. Add two delightful models, and the Key Route has a public relations triumph. A new train car image was needed to complement Key's two new 1927 "Floating Palaces," the ferries *Peralta* and *Yerba Buena*. Only a minority of cars received this paint scheme. (Randolph Brant collection.)

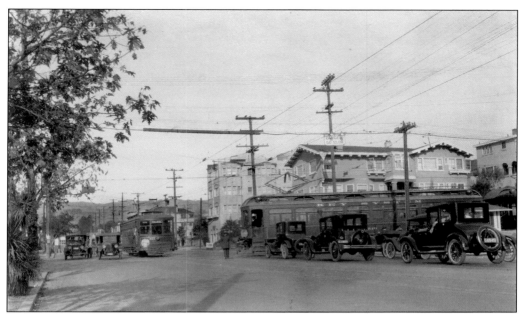

The intersection of Broadway and Fortieth Streets was a busy rail and vehicular crossing. Very soon, Piedmont commuters will be traveling to the ferry terminal, and then they will ride the ferry to San Francisco—a most "civilized" way to commute. (Randolph Brant collection.)

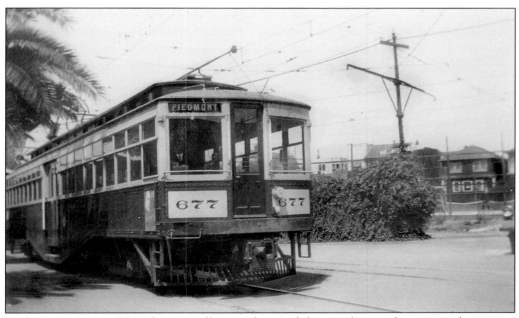

Piedmont Car No. 677 is showing off its rendition of the new livery of orange and cream in the early 1930s. The Depression is on, and the cars are not filled as much as in previous years. Nevertheless, all that would soon change at this locale. The original Piedmont depot would be replaced with a new one reflecting the style and needs of a different time. Even the 650s Class cars would be replaced by new ones. (Randolph Brant collection.)

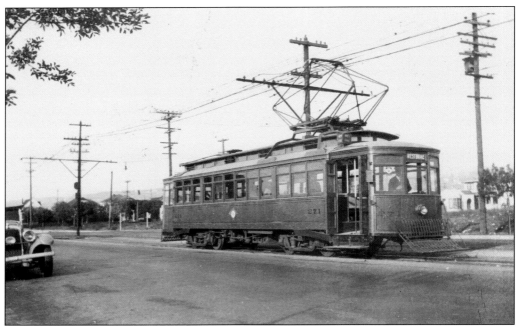

The Lehigh cars, purchased by the Smith interests, found many uses; their final was to pull trailers on the streetcar line to Richmond, which was abandoned in 1933. Car No. 271 was then placed on the G Westbrae line as a shuttle car. While the rest of this class was scrapped in 1935, No. 271 soldiered on until it was abandoned in 1941. Reprieved by World War II traffic demands, it was saved from the scrapper's torch to become the first car of the collection of the Bay Area Electric Railroad Association. (Randolph Brant collection.)

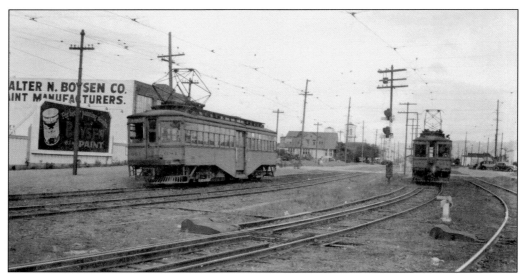

Judging by the two single 650 Class cars, No. 681 on Sacramento Street and No. 678 on Adeline Street, both inbound to the pier, it must be a Sunday outing for this unknown photographer. Soon both cars, thanks to the tower man at Tower No. 4, will be running on the same Linden Avenue trackage. (Randolph Brant collection.)

Just how futile was the competition between Key and the SP? To judge, look at Key's Sacramento Street line near Alcatraz Avenue in Berkeley in the early 1930s. With the SP's California Street line one block to the east, both lines served an underpopulated territory. (Randolph Brant collection.)

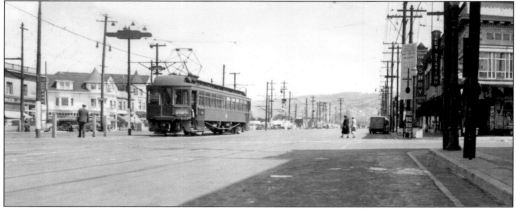

In March 1933, following the agreements between Key and SP, the Berkeley trains, which formerly terminated in downtown Berkeley, now ran only as far as Adeline Street and Alcatraz Avenue. This left downtown Berkeley as exclusive SP territory. Eight years later, Key would extend itself again into downtown Berkeley, using now-abandoned SP tracks, and further extend itself to Northbrae. (Randolph Brant collection.)

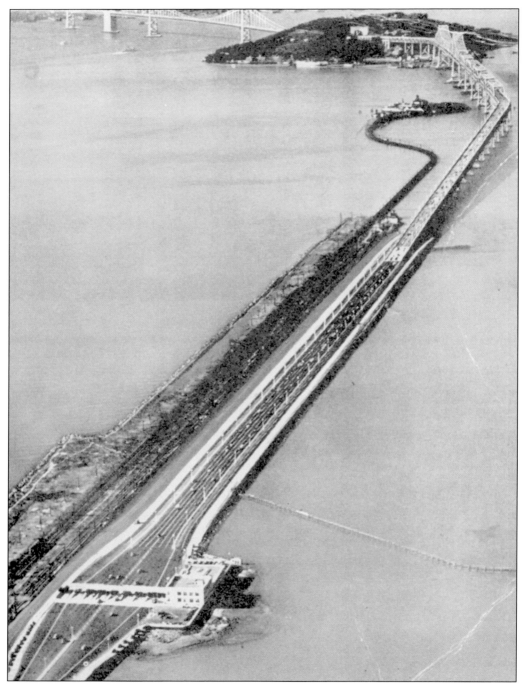

The Bay Bridge opened for cars, trucks, and buses on November 12, 1936, six months before San Francisco's Golden Gate opened and over two years before the Bay Railway opened in January 1939. In this late 1936 scene, looking west from the east shore of San Francisco Bay, Key patrons were still reaching San Francisco via trestle, pier, and ferryboat. (Photograph by Stanley Piltz; Emiliano Echeverria collection.)

Three

CROSSING THE WATERS OF SAN FRANCISCO BAY

Central to Key System's competitive successes and its economic survival was the crossing of San Francisco Bay. Several components made up the transbay crossing—the 3.36-mile-long trestle, the Pier Terminal, the company's ferry fleet, and lastly its San Francisco moorage, the Ferry Building. All of these components had to operate in a coordinated, safe, efficient manner to ensure the company's riders returned and increased in numbers.

As ridership increased during the 1910s, the number of ferryboats and their capacity likewise increased. Boats, such as the ill-fated *Peralta* built in the 1920s, accommodated 4,000. With sudden human hordes of this magnitude, ferry and train movements had to be precise. There was no room for a causal operation.

The ornate structure that was the pier changed forever the night of May 6, 1933, somewhere between 9:53 p.m. and 9:58 p.m., when an unknown arsonist using a marine flare ignited the pier. When the conflagration subsided, the pier was in ruins, and the ferryboat *Peralta* was a total loss, along with 14 cars. Key's service was crippled for nearly a year.

With the Bridge Railway on the horizon, the replacement pier terminal was prudently scaled down; it had only one passenger-loading slip. The terminal was an all-steel structure, rendering it fireproof and allowing for easy disassembly and subsequent sale.

As ridership surged, topping over 15 million by 1920, larger and fewer ferries were needed to avoid operational delays. Most of the ridership gains were concentrated during the morning and evening rush hours; capacity had to accommodate this peak demand, but it also curbed profitability.

This need for newer, larger ferryboats was enhanced by the 1919 loss of the *San Jose* to fire. The solution was the world's first turboelectric-driven ferryboats—the *Hayward* and *San Leandro*—which entered revenue service in 1923. Ferryboat riders would now enjoy a smooth, quiet ride, operating costs were reduced, and steel hulls had replaced wood.

Two more still larger new ferries (Key's last) entered service in 1927—the twin "Floating Palaces," as dubbed by Key's marketing department. The *Peralta* and *Yerba Buena* continued the tradition of turboelectric-driven ferryboats. Except for the wheelhouse, because of problems with radio reception, they were of all-steel construction. Their appointments rapidly earned praise as "elegant" and "exquisite."

Transbay ferryboat service ended Saturday, January 14, 1939. The next day the Bridge Railway was born. Twice, in 1939 and 1940, ferry service was restored to serve the World's Fair on man-made Treasure Island. Service was offered both from a rebuilt Key Pier (1939 only), with passengers arriving on X-Exposition trains that served all six transbay lines, and from San Francisco's Ferry Building. Key System had operated ferries from the Key Pier to a specially constructed pier at Gashouse Cove (today part of the Marina Yacht Harbor) during the San Francisco's 1915 Panama Pacific International Exposition.

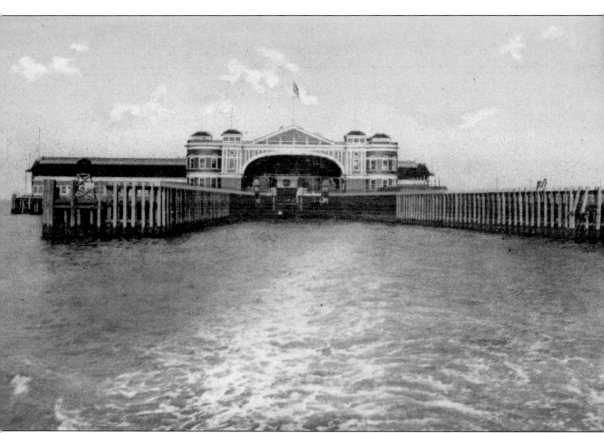

The grand architecture of the San Francisco, Oakland & San Jose Railway pier reflected not only the taste of its principal entrepreneur Francis Marion "Borax" Smith, but conveyed to all the world that the company was substantial and, more importantly, a worthy competitor to its established rival, the Southern Pacific Railroad. For 20 years, from 1903 to 1933, Key System's passengers passed through this ornate structure that was reminiscent of Borax Smith's grand Key Route Inn and Claremont Hotel. The pier's ferry dock is seen from a departing San Francisco ferry in 1903. (Randolph Brant collection.)

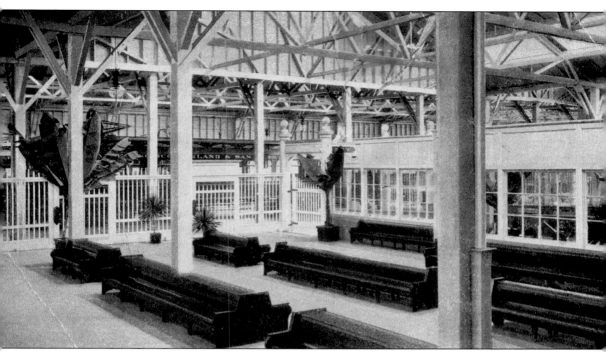

Very few persons would have an occasion to use the pier's waiting room, pictured here before the start of service in 1903. For most, it was a dash from the train to a waiting ferry or the reverse. Only the timid and slow afoot may miss the connection and require use of the benches in the waiting room. Also, on those rare occasions when a service disruption occurred, the waiting room provided a temporary sanctuary for the stranded. (Randolph Brant collection.)

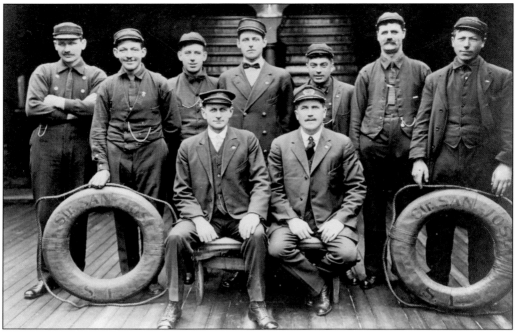

Shortly after the October 1903 start of revenue ferry service, the officers and some of the crew of one of Key's ferries, the *San Jose*, are posed for a photograph. Reflecting Borax Smith's dream for the scope of his electric railway empire, the first two ferries were named *San Jose* and *Yerba Buena* (the original name for San Francisco). Smith was not that subtle in naming the third double-ended wooden hull ferry (1905); it was christened the *San Francisco*. The wooden-hulled, steam-powered fleet was rounded out with the addition of the *Claremont* (1907) and the *Fernwood* (1908); names designed to promote real estate development. (Sappers Collection, BAERA Archives 32141.)

In this classic 1908 view, looking east, part of the Yerba Buena Yards (in the right foreground) with the Key Route subway under the Southern Pacific mainline is visible. Adjacent to the yards are stored off-peak 500s, and in the background are the Yerba Buena powerhouse and Tower Two, where Twenty-second Street and (later) Twelfth Street diverge south toward central Oakland. (Randolph Brant collection.)

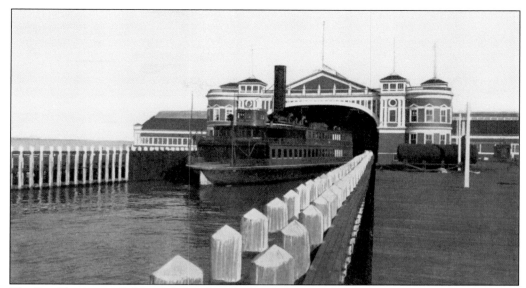

The San Francisco, Oakland & San Jose Railway's first two ferryboats were named on behalf of the company's corporate title terminal cities—the *San Jose* and the *Yerba Buena*, the first name of San Francisco. The *Yerba Buena*, moored in 1904 at the pier shortly after the start of service, would ply the waters of San Francisco Bay on behalf of Key until 1925. (Randolph Brant collection.)

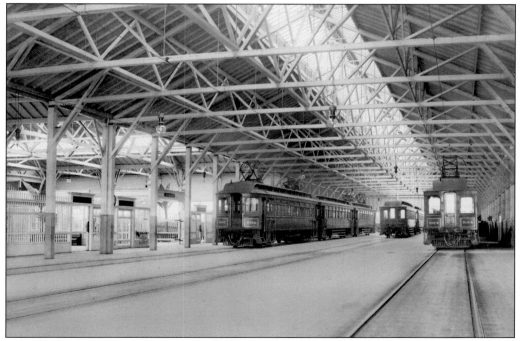

In 1907, the company photographer picked a quiet time, probably a Sunday morning when most of the Eastshore Empire residents were still in bed or at church, to take this picture of the pier's train shed with its handsome 500s enjoying a rest. Ferry service during such off-peak times was every 40 minutes instead of the normal 20-minute headway. Soon the 500s would be rumbling on the streets of Oakland and Berkeley, as they did for 35 years. (Randolph Brant collection.)

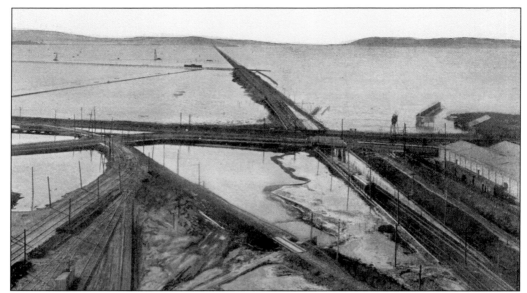

An unknown intrepid photographer scaled the smokestack of Yerba Buena's powerhouse to shoot this panorama in 1907. Starting on the lower right are Key's dual tracks, a three-car inbound train of 500s, the subway under the Southern Pacific's mainline, and finally the 3.26-mile trestle into San Francisco Bay. However, during 1908, because of inferior initial construction and poor maintenance, Key was forced to replace with fill the first 1,680 feet of the westward trestle. Five years later, another 5,585 feet of fill was added, and a new trestle, 3,850 feet in length, was constructed to the deepwater ferry pier. Service over this new alignment began on May 16, 1916. (Randolph Brant collection.)

This 1909 track-level view of the Key Terminal Pier trackage shows the complexity of the track work required to support the company's transbay lines. By the late 1910s, the Key System Pier had expanded from its original three-track, single-ferry berth to three ferry slips and nine tracks. With six separate Key pier lines, plus trains of the predecessors of the Sacramento Northern, trains had to arrive, unload, load, and depart on cycle that had ferryboats arriving and departing every 20 minutes—a task of considerable logistical coordination. (Randolph Brant collection.)

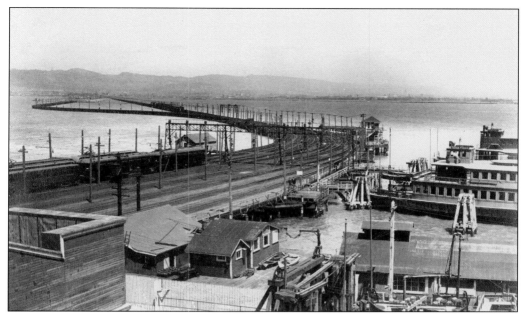

The year is 1915, and both the original pier trestle (on the right) and the new yet to be opened replacement trestle are visible. The conversion date to shift all operations to the new trestle alignment was May 16, 1916. Docked at non-passenger slips are the ferryboats *San Francisco* and the *Yerba Buena*. Because of increased traffic on the double-track land and trestle line from Fortieth Street and San Pablo Avenue to the pier, the company installed automatic General Railway Signal block signals in 1911, and tripper arms were added to the roofs of transbay cars. If a train ran a red stop block, the tripper arm would trigger the emergency brakes. (Randolph Brant collection.)

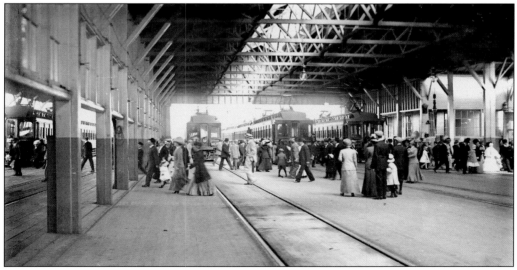

Here, in 1915, trains and a ferry have arrived at the Key Route Pier Terminal, but will soon depart again after passengers have transferred from one mode of transportation to another. Key's passengers of the period, by their dress, were upscale and worthy of riding on one of the company's handsome 500s. (Sappers Collection, BAERA Archives 16378.)

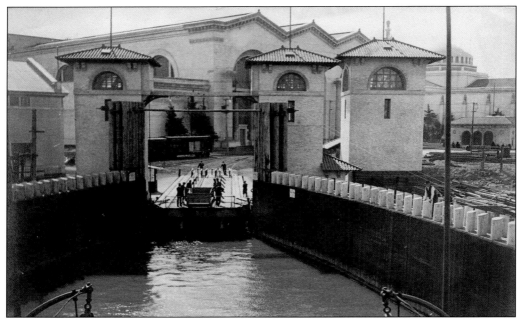

Thanks to Key System, Eastshore Empire residents had direct ferry service from the Key Route Pier to San Francisco's 1915 Panama Pacific International Exposition. Key's exposition ferries docked at a specially constructed pier at Gashouse Cove, today part of the Marina Yacht Harbor. Very soon, this Key ferry will disembark its Eastshore Empire passengers to revel in the joys of the exposition. (Sappers Collection, BAERA Archives 32139.)

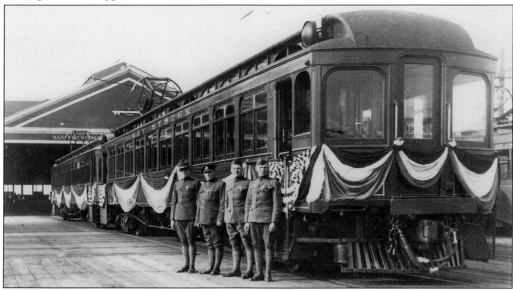

The Great War, as World War I was then known, was over. Patriotism abounded, and the Key System was not immune from the feelings of the time. A decorated set of handsome 500s waits, complete with an honor guard of World War I–decorated Key System employee veterans, who will run the special train carrying General Pershing and his party to Berkeley in 1918. (Randolph Brant collection.)

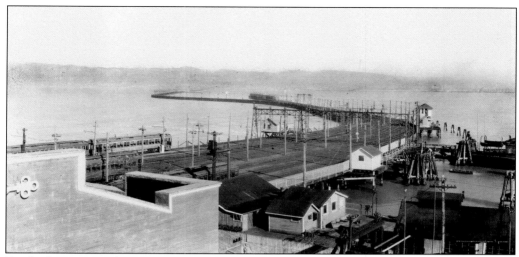

By the late 1910s, the Key System Pier had expanded from its original three-track, single-ferry berth to three ferry slips and nine tracks. With six separate pier lines, plus trains of the Sacramento Northern (and its predecessors), trains had to enter and leave in rapid fashion. This must be a Sunday; all other days the pier's nine tracks were full of trains coming, waiting, and going, and commuters were always on the run. When this 1920 eastward-looking view of the pier and trestle was made, the second trestle alignment had been in service for four years. (Randolph Brant collection.)

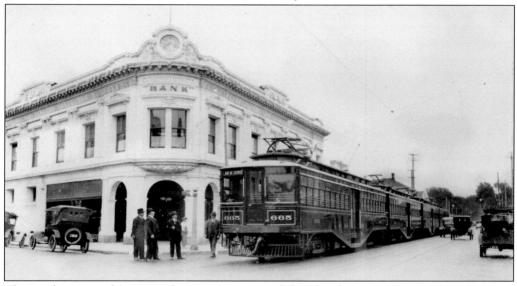

The good citizens of San Leandro must have turned their heads in amazement. What is a train from the Key System 650 Class doing in their city? Key System ran a special VIP train to both San Leandro and Hayward to commemorate the August 1923 inauguration of the world's first turboelectric-driven ferryboats—the *Hayward* and *San Leandro*. Always entrepreneurial, Key's ferries sold to its short-time captive audience newsstand items—magazines, newspapers, candy, tobacco products, and food items, one of which was the famous Key Route hash. Key even employed bootblacks. As newer ferries were added, the amount of space devoted to these services increased. (Randolph Brant collection.)

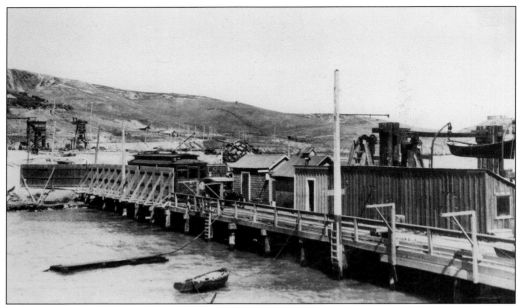

After Borax Smith acquired the Eastshore & Suburban Railway in 1912, he had a second but lesser known bay ferry connection—the Richmond and San Rafael Ferry Pier. Unlike the service from the Key Pier to San Francisco, the connecting ferry service to San Rafael was always independent of Key ownership. A No. 2 streetcar heading for Berkeley and Oakland is on the original Richmond rustic pier in 1921. (Randolph Brant collection.)

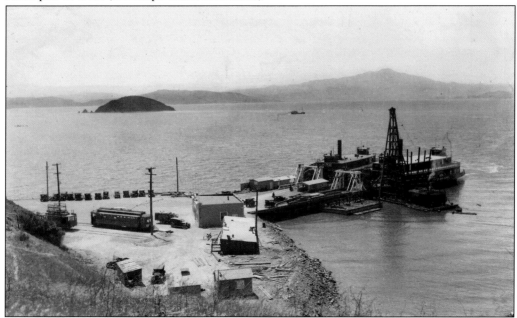

In sharp contrast to the grand style of the Key Route Pier was the spartan Richmond Pier of the Richmond-San Rafael ferry. Here ex-Lehigh Car No. 272 waits to start its trip on the No. 2 line streetcar, while passenger/auto ferries—the *City of Richmond* and the *City of San Rafael*—are moored in 1932. (Randolph Brant collection.)

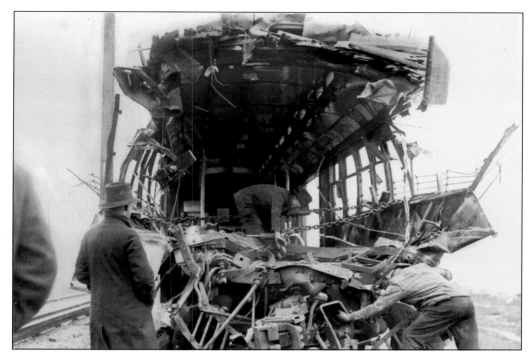

Key System's worst fears came to realization on the foggy morning of December 4, 1924. Because of an equipment problem, westbound pier trains began to stack up on the trestle. Although the block signals worked, a speeding Sacramento Short line train, led by No. 1014, could not stop in time. It telescoped into the rear of a 650 Class Twelfth Street train. Eight fatalities resulted; most in Car No. 665, pictured here after the cars were separated. (Randolph Brant collection.)

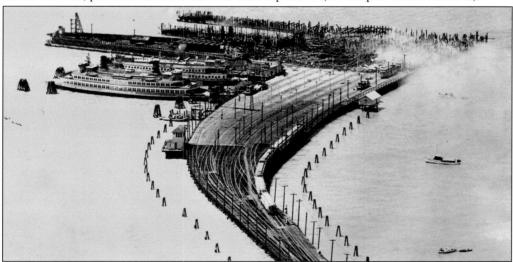

Key System had its share of disasters. The worst disaster occurred on the night of night of May 6, 1933. Sometime between 9:53 p.m. and 9:58 p.m., an unknown arsonist using a marine flare ignited the pier. The arsonist was successful. Smoke was still rising as the photographer attempted to document the scope of the damage. The pier and train shed were destroyed, and Key's service would be crippled for nearly a year. (Sappers collection, BAERA Archives 32119.)

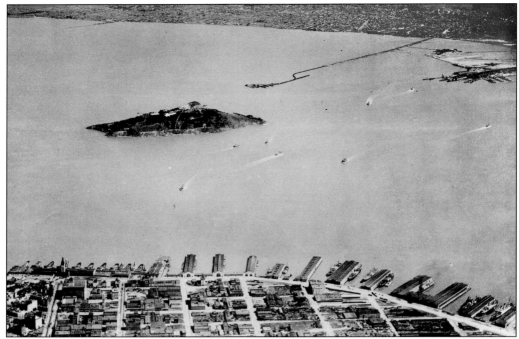

This magnificent 1929 aerial view illustrates the penetration of the San Francisco Bay's waters near the Key Route's trestle and pier. Key's goal was to shorten the distance of the slower water journey to the Ferry Building (lower left), where their ferries were moored at the north end. The prize was a faster transbay trip than rival Southern Pacific. If hoards used the Key Pier, then throngs used the Ferry Building, and the design of the structure moved the throngs efficiently. Looping in front of the Ferry Building was a continual stream of city streetcars. The piers of San Francisco's southern Embarcadero are visible here. (Sappers collection, BAERA Archives 31323.)

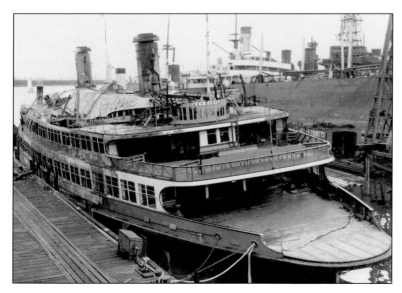

Despite its all-steel construction (except for the wheelhouse), the *Peralta*'s upper works were badly damaged by the 1933 pier fire. It was then sold to a scrapper, where its burned-out hulk rested in the scrapper's slip. Soon it would be resold, rebuilt, renamed *Kalakala*, and placed into Puget Sound service. (Sappers collection, BAERA Archives 32149.)

President Lundberg ordered that the replacement for the 1933 fire-destroyed Key Pier Terminal be of economic and utilitarian design. Soon the Bridge Railway would end the San Francisco ferry connection. This was also during the depth of the Depression; "Happy Days" had yet to arrive. Resting beneath the under-construction framed train shed in 1934 are 500s and 650s. (Randolph Brant collection.)

Key's new terminal is under construction in 1934 as the orange-painted *San Leandro* and *Hayward* rest between trips in non-passenger slips. As the world's first turboelectric ferryboats, they offered a smooth quiet ride compared to older steam-powered vessels. (Randolph Brant collection.)

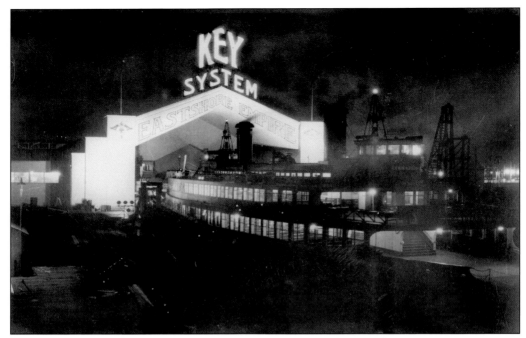

Key's president Alfred J. Lundberg knew the value of maximizing his company's image. He commissioned this classic nocturnal view of the Key Pier after the fire. Its purpose was simple—to end any comparison (which would be negative) of the new with the old—and this photograph attests to his success. The ferry *Yerba Buena* is docked at the single slip in 1934. (Randolph Brant collection.)

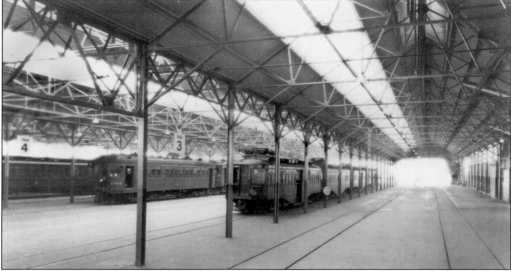

Key System had a tenant—the Sacramento Northern Railway (and its predecessors). By means of a separate coupon, Key kept all of the revenues generated by Sacramento Northern passengers when traveling over its lines. On track No. 4 during the 1930s, a Sacramento Northern train, headed by No. 1005, is waiting for passengers from the next ferry bound for Sacramento, Chico, Maryville, and the way stations. (Randolph Brant collection.)

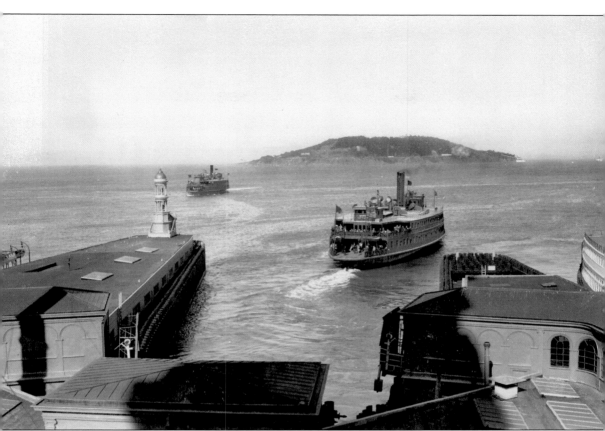

Hayward, along with her sister the *San Leandro*, was among the most modern ferryboats anywhere. After Key service, she and her sister ship performed duty for the army during World War II. The *Hayward* was scrapped in 1947, while the *San Leandro* was sold to the SP and used in transbay ferry service until July 1958—outlasting the Bridge Railway by three months. (Sappers collection, BAERA Archives 32144.)

YOUR TRIP

TO TREASURE ISLAND IS "A PART OF THE PARTY" WHEN YOU TRAVEL QUICKLY, EASILY AND INEXPENSIVELY

via KEY SYSTEM

● THE EXPOSITION begins for you when you march to martial music aboard the Ferry for your gay trip to Treasure Island. Your ride, whether from San Francisco's historic Ferry Building or Oakland's Key Pier, will have the romance of years of Ferry travel plus thrilling anticipation ... plus some highly practical considerations.

These only Key can give you. There's EASE! No traffic struggles. No parking worries. There's ECONOMY! No unnecessary car expense. No 50-cent bridge tolls or 50-cent parking. Your ferry fare is just 10 cents. 5 cents for children between 6 and 12. And that, plus San Francisco car fare or Metropolitan Oakland train fare (one token or 10 cents with full transfer privileges) is all

OPENING DAYS' SERVICE

● FROM SAN FRANCISCO boats for 8:00 a.m. gate openings on Saturday and Sunday leave shortly after 7:30 a.m. Continuous service thereafter. Last boat returns at 2:00 a.m.

● FROM METROPOLITAN OAKLAND Key trains leaving terminals on all lines at shortly after 7:00 a.m. connect with Island Ferries. Twenty-minute headway thereafter. Last boat returns at 2:25 a.m.

● HAVE EXACT FARES before reaching turnstiles at Ferries Change booths with uniformed girl attendants are located conveniently.

RIDE THE ELEPHANT TRAIN
Point-to-point, 10c Sightseeing.

● You'll see more ... visit ... saving time, steps and money, when you make it a habit to use the fascinating Elephant Trains. A sightseeing tour right at first will help you plan future visits or the same day's trip. Skilled lecturers will be a real help to you.

● Lounge on deck or in comfortable seats near wide windows and watch the approach of the Fair at its fairest. Or relax in a luxurious, brilliantly appointed cocktail lounge.

You're there all too quickly. The Island is 12 minutes from the Ferry Building, 9 minutes from the Key Pier on the east shore. And you're there in top shape .. physically, mentally and financially ... for the time of your life.

For speed, ease, comfort, economy and downright luxury, leave car and care behind and ... "ride the ferries to the Fair."

KEY SYSTEM
"A Part of the Party"

SERVING SAN FRANCISCO AND THE CITIES OF THE METROPOLITAN OAKLAND AREA WITH QUICK, EASY, INEXPENSIVE TRANSPORTATION TO AND FROM TREASURE ISLAND

There were no bridge tolls or parking fees for Key Route fairgoers. This Treasure Island advertisement points out the cost of automobile travel compared to the Key where "you travel quickly, easily and inexpensively via Key System." What a year 1939 was for Key—the opening of the Bridge Railway and a major fair, too. (Val Lupiz collection.)

SCHEDULES
FERRY SERVICE from SAN FRANCISCO
Train-Ferry Service from Metropolitan Oakland
TO
TREASURE ISLAND
Wednesday, Thursday, Friday, Saturday and Sunday

From San Francisco

Ferry service from the Ferry Building to Treasure Island will operate on the following schedules starting today and continuing through Sunday. —

For Exposition Employees

For the convenience of persons employed on Treasure Island, ferries will be operated at—

6 a m. and every 40 minutes to 8:00 a. m.
8 a. m. and every 20 minutes to 9:20 a. m

For Exposition Patrons

Quick, easy, economical service for visitors to Treasure Island on luxurious Key ferries at—

9:40 a. m:. 10 a. m. and every 15 minutes throughout the day until 12 midnight

Thereafter ferries will leave on the following schedule—

12:20 a. m., 12:40 a. m., 1:00 a. m., 1:40 a. m., 2:20 a. m., 2:40 a. m.

To San Francisco

From the Exposition to San Francisco, Key ferries will operate from the West Ferry terminal to the Ferry Building at—

6:20 a. m. and every 40 minutes to 8:20 a. m.
8:20 a. m. and every 20 minutes to 10:40 a. m.
10:40 a. m. and every 15 minutes to 12:40 a. m.
1:00 a. m., 1:20 a. m., 2:00 a. m., 2:30 a. m., 3:30 a. m.

From Metropolitan Oakland

Visitors to the Exposition from the entire Metropolitan Oakland area will find economy and convenience in Key service on all regular lines. Today and on Sunday, trains will operate every 20 minutes from first times shown below. On Thursday, Friday and Saturday, service will be every 40 minutes from first times shown.

12th St. "X" train leaves 3d Ave. and E. 18th St.— 9:12 a. m.
22d St. "X" train leaves Wesley Ave.—9:14 a. m.
Piedmont "X" train leaves Piedmont Ave. and 41st St.—9:25 a. m.
Claremont "X" train leaves College Ave.—9:20 a. m.
Adeline St. "X" train leaves South Berkeley— 9:26 a. m.
Sacramento St. "X" train leaves University Ave.— 9:20 a. m.
Alcatraz Ave. "X" train leaves Bancroft and Telegraph—9:20 a. m.

Remember, today and Sunday every **20** minutes beginning with time shown above. Thursday, Friday and Saturday, every **40** minutes.

For Exposition Employees

Special trains will operate from Yerba Buena (40th and San Pablo) at the following times—
6:00 a. m., 6:40 a. m. 7:20 a. m., 8:10 a. m., 8:50 a. m.

To Metropolitan Oakland

Ferries connecting with trains on all lines will leave the East Ferry terminal on Treasure Island every 20 minutes today and Sunday, every 40 minutes on Thursday, Friday and Saturday from 10:05 a. m. to 1:25 a. m. Last boat at 2:25 a. m.

KEY SYSTEM
"A Part of the Party"

"Part of the Party" was the promotional slogan for Key System's special ferry train services to the 1939 World's Fair on man-made Treasure Island. Services were operated from San Francisco and the Eastshore Empire for both fair workers and visitors. (Emiliano Echeverria collection.)

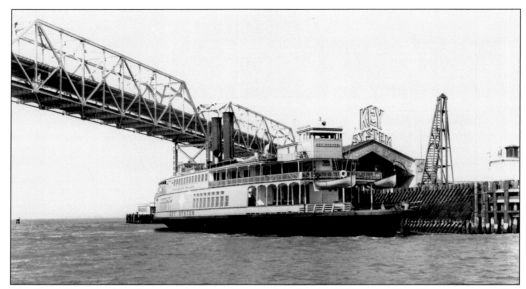

The ferry *Treasure Island*, moored on a quiet non-fair day in 1939 at the Key Pier, went into Key System service in April 1938 to transfer construction workers and personnel to Treasure Island to build structures for the World's Fair. Pictured above the pier is the reason why all Key ferry service ended—the San Francisco-Oakland Bay Bridge. (Sappers collection, BAERA Archives 32151.)

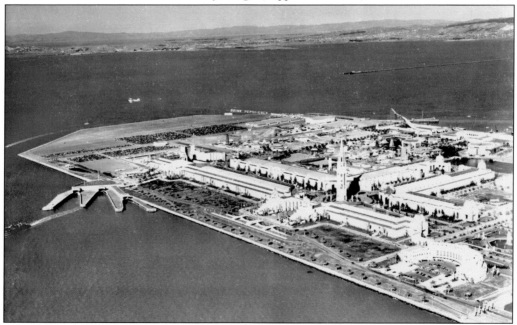

The World's Fair on Treasure Island was a bonanza traffic generator for Key. The scope, scale, and glamour of this World's Fair must have provided a magical interlude for a Depression-weary populous. For the 1939 season, Key operated on 40-minute headways, connecting X-Exposition trains on all six transbay lines with ferry service, plus direct ferry service from San Francisco's Ferry Building. In 1940, buses replaced the X-trains, but San Francisco's ferries returned. The ferry slips are pictured on the lower left. (Sappers collection, BAERA Archives 32150.)

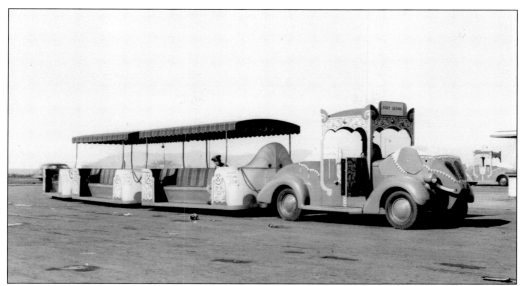

After Key Route patrons disembarked from their swift ferry journey to the Golden Gate International Exposition, Key System would take fairgoers to the fairgrounds for 10¢ on "elephant trains." For 35¢, fairgoers could have a guided elephant train tour. In reality, elephant trains were dressed-up sightseeing tractors with trailers. This image was taken in October 1939. (Walter Rice collection.)

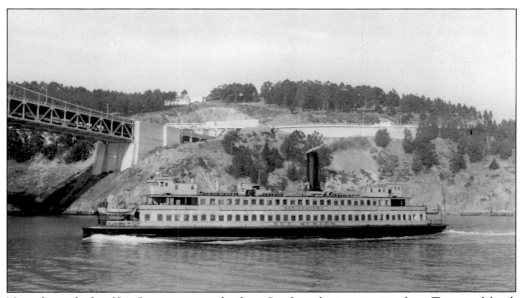

Near the end of its Key System career, the ferry *San Leandro* is returning from Treasure Island, the site of the Golden Gate International Exposition, to San Francisco's Ferry Building to pick up more excited fairgoers. For fair service, Key added a cocktail lounge to the *San Leandro*. (Walter Rice collection.)

Until 1941, Key had a policy of not accepting local streetcar transfers on its transbay trains. In order to provide transbay service to South Berkeley, the Alcatraz–College Avenue line was formally made part of Key's transbay system in 1912, upgraded and coordinated to meet Berkeley line transbay trains. Here, during the 1930s, a two-car set of streetcars waits at Adeline Street and Alcatraz Avenue for the next train from San Francisco. The sign post reads, "University Avenue, Greek Theatre." (Randolph Brant collection.)

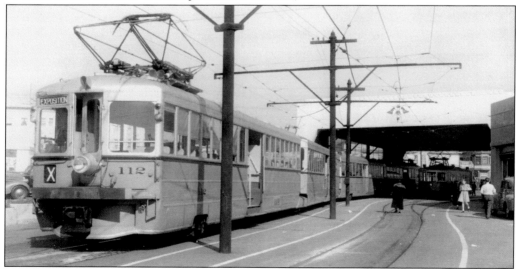

On all of its six 1939 transbay lines, Key System operated special trains designated "X" to serve Treasure Island's Golden Gate International Exposition. For this service, the Key Route Pier and ferryboats were used once again. Exposition trains serving the Fortieth Street–Piedmont line began at the Piedmont Station with a connecting Oakland Avenue streetcar shuttle. Outbound from Pier 112 and mate will be signed "C" in order to differentiate them from trains serving one of the other five lines. (Walter Rice collection.)

Four

THE 1930S BRING BIG CHANGES

In 1911, after Southern Pacific created electric lines, the Key Route had a worthy competitor. By 1920, Key's transbay market share was only slightly larger than 40 percent. Until 1924–1925, both companies enjoyed more passengers. After 1925, ridership began to erode away. Management of both companies clearly realized the transbay service had been overbuilt.

On March 26, 1933, the California State Railroad Commission approved the plans of Key and Southern Pacific to eliminate transbay duplication. Key abandoned its Berkeley line north of Alcatraz Avenue. The outer end of Key's Sacramento Street Northbrae line was rerouted over SP's abandoned California Street line to Monterey and Colusa Avenues. In addition, Southern Pacific abandoned its Berkeley Ellsworth Street line and its downtown Oakland Eighteenth Street line, leaving downtown Oakland as Key territory.

Early in Lundberg's tenure, he had been successful in eliminating conductors on the city streetcar lines. His platform labor-saving car for transbay services was the articulated car. During 1931, two center-entrance 650 Class cars—Nos. 650 and 662—emerged from the Emeryville Shops as a single articulated unit. A two-car train of 650s required a motorman and two conductors. The articulated unit required only a motorman and a single conductor. The savings were even greater if articulated units were coupled together. Each coupled articulated unit had, in effect, half a conductor per car.

Once it became evident the Bay Bridge would be built and upon it a Bridge Railway for Key (with its tenant Sacramento Northern) and the Southern Pacific, the 500 Class wooden interurbans would not be acceptable. The experimental articulated prototype was the answer. Over a three-year period, starting in 1935, the 500 wooden class and the 650s were removed from service and scrapped, with many of their parts recycled into 88 "new" articulated bridge units, Nos. 100–187.

Others argued that the new cars were essentially old cars with new outside shells, and that Key had foregone the latest technological advances. This was partially true. All new cars of this design would have needed an extra $500,000 to order. Because cash was very short, and Key had lost over three million annual transbay riders since 1930, using recycled parts that were rebuilt and upgraded before being used seemed the way to go. Given the uncertainties associated with the new bridge rail operation—would it restore ridership?—combined with the real fiscal constraints management faced, the Lundberg decision of recycling as much as possible appeared to be the sole viable course of action.

Key sold land to the state, which allowed it to cover much, if not all, of its conversion out-of-pocket costs. Lundberg also got state money to cover $2.47 million of the $3.5 million cost of the new cars. With the Bridge Railway, Lundberg recognized the transbay lines would have a higher average speed compared to Key's local lines, and thus would generate higher revenue per car hour. The first Key revenue train, off of the Twenty-second Street line, arrived in San Francisco at 6:17 a.m. on Sunday, January 15, 1939. The new era had begun.

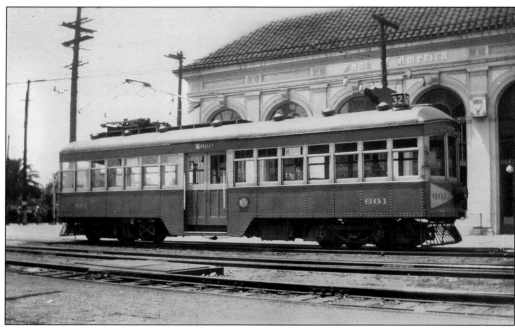

One of three former Southern Pacific center-entrance dinkies that Key purchased and rebuilt in 1930, this is No. 601 at Fortieth Street and San Pablo Avenue, in Emeryville, in 1931. These cars were painted green and cream and carried an East Bay Street Railways Limited emblem. The short-lived 32-line was the Piedmont Fortieth Street–Berkeley Ward Street shuttle. Both No. 601 and the 32-line were history by 1934. (Randolph Brant collection.)

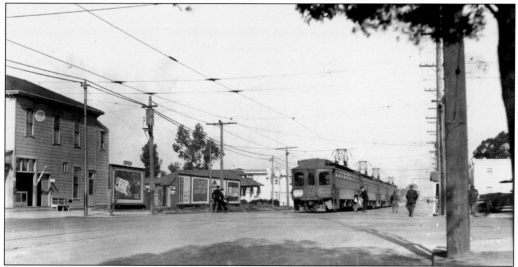

The newspaper boy has made a sale—one more *Oakland Tribune* sold, one more reader updated about the latest doings of Franklin Roosevelt's New Deal. Behind him, a set of five 500s roll along Fortieth Street during the 1930s. The length of this Fortieth Street–Piedmont train is over 325 feet. However, high-capacity, fast-loading cars that saved labor costs were to the frugal, Depression-era Key management the only viable solution for the future Bridge Railway, not the 500s. (Randolph Brant collection.)

A single pier-bound 650 Class car, No. 664, pictured here on former IER Monterey Avenue trackage, is more than ample to meet the Sunday demand on the Sacramento Street line in the mid-1930s. No. 664, along with No. 663, were the only two 650 Class cars to have their deck roofs replaced with a steam-coach roof as an experiment to strengthen the car. (Randolph Brant collection.)

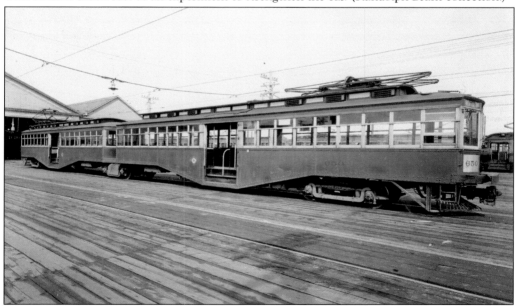

A goal of Key president Lundberg was to reduce operating costs by productivity increases. During 1931, two center-entrance 650 Class cars emerged from the Emeryville Shops as a single articulated unit, No. 650. One conductor was eliminated. Because of its gigantic length, it was nicknamed the "Akron" in honor of the Moffett Field–moored blimp in Sunnyvale. Importantly, the new No. 650 became the prototype for the bridge units. The "Akron" is at the pier in Key's temporary orange and cream colors in 1932. (Photograph by Moses Cohen; Randolph Brant collection.)

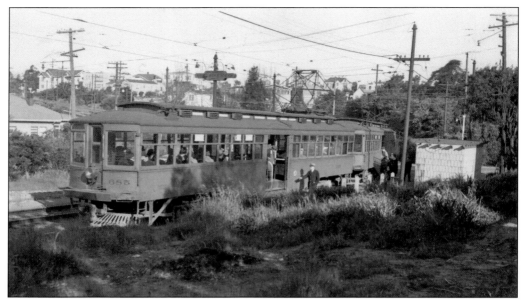

"Happy Days" are yet to come. The well-filled Fortieth Street–Piedmont train belies the fact that the business cycle is in the trough of the Great Depression. Here Car No. 685 and its mate are loading at Arroyo Avenue Station in 1934. (Walter Rice collection.)

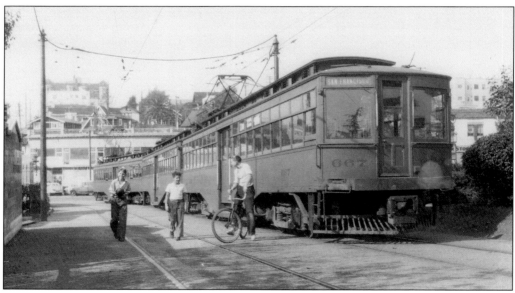

A set of three 650 Class cars bound for the pier are stopped at the Wesley Avenue Station on the Twenty-second Street–Grand Avenue line in October 1936. The set's crew size is four—a motorman and three conductors. Within two years, this schedule will be serviced by two large-capacity bridge units and a crew of only three—a motorman and two conductors. (Walter Rice collection.)

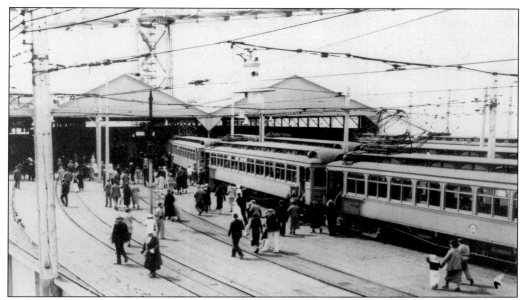

Here the old meets the new. Key's venerable 500s are in their swan song as they come and go from the new pier terminal, built to replace the ornate wooden terminal destroyed by fire. With the Bay Bridge in the background, the future is plain to see. (Walter Rice collection.)

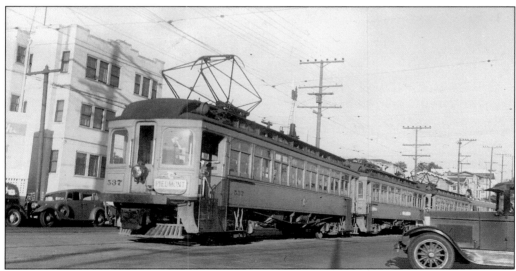

Piedmont-bound Car No. 537 is on Fortieth Street approaching Broadway in 1937. The Key has recently adopted letters to designate their various lines. The SP, which became the Interurban Electric Railway (IER) in 1938, chose to use numbers. The letters were welded to the existing dash signs and presented an awkward appearance on these otherwise graceful cars. (Randolph Brant collection.)

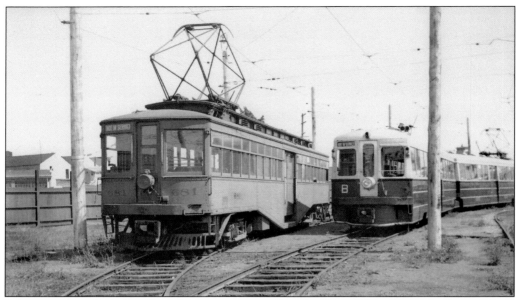

Believe it or not, both the all-steel, center-entrance Car No. 681 and the adjacent bridge unit from the 101–104 series have a lot in common. Both were homebuilt products from Key's Emeryville Shops—No. 681 in 1925 and the bridge unit in 1937–1938. Units 101–104 were each rebuilds from a long and short 650 Class car. Key's purpose for this 1937–1938 photograph was to contrast the old and new. (John F. Bromley collection.)

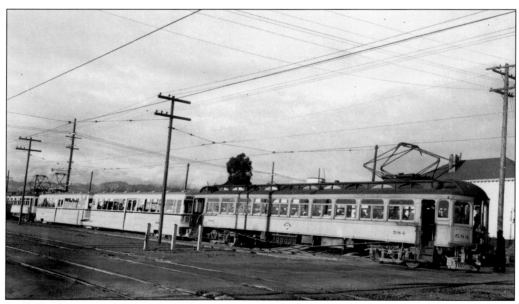

In 1937, Claremont Avenue–bound commuters had their choice of riding in No. 584, constructed in 1911–1912, or bridge Unit No. 173, which was built entirely new (except for the pantograph) in 1937 by Bethlehem Steel Company. The new units, Nos. 165 to 187, were purchased to allow Key to retire the 500s and 650s for bridge unit rebuilding purposes. During 1938, it was routine to have 500s and 650s in "MU" operation with the new cars. (Randolph Brant collection.)

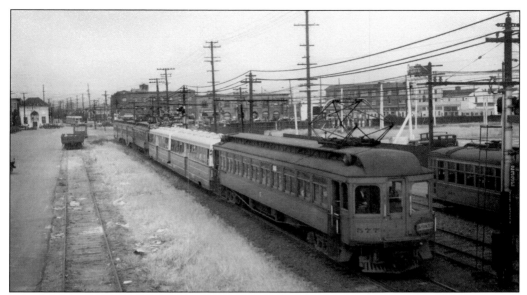

Which car would passengers want to ride—the "Apartment House Five" No. 577, the brand-new bridge unit, the second wooden five, or one of the trailing 650 Class cars? Since all classes of transbay cars had the same electrical equipment, such a diverse mixture was no special feat. (Randolph Brant collection.)

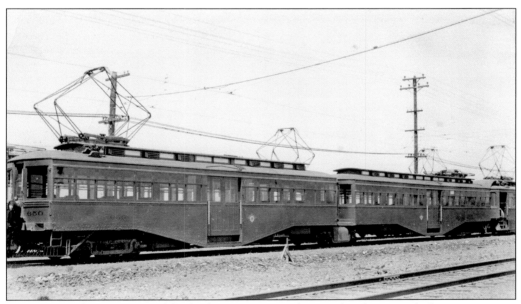

During 1931, the prototype of the bridge units—a single articulated unit made from two center-entrance 650 Class cars—rolled out of the Emeryville Shops. Compared to the two coupled 650s, the articulated units needed one less conductor and, in effect, each had half a conductor per car. This prototype rests at the Yerba Buena Yards prior to journeying to the Emeryville Shops to be rebuilt into bridge Unit No. 100 in 1937. (Randolph Brant collection.)

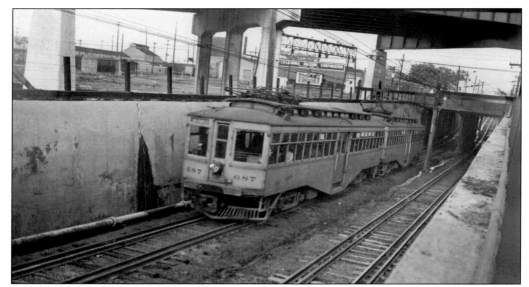

A brace of Key Pier–bound, all-steel, center-entrance 650 Class cars, led by No. 687, passes beneath Southern Pacific's mainline track in 1936. Soon the 650 sub-series, Nos. 677–688, would be removed from service and scrapped with the parts being recycled into bridge units 111–124. (Randolph Brant collection.)

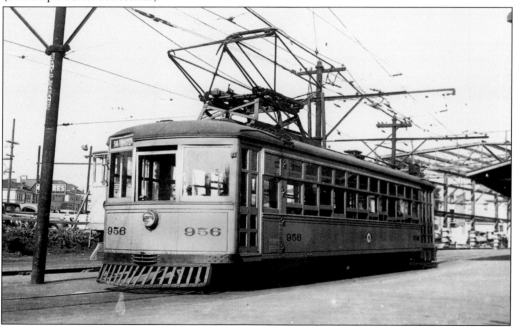

For reasons of economy, the Fortieth Street–Piedmont Line operated a connecting streetcar shuttle from Piedmont Station to Oakland Avenue during off-peak hours. Before 1931, the shuttle cars were from the 650 Class, which, unlike the 500s, could navigate the lines' streetcar radius curves. Since the 650 Class cars were a two-man operation, they were replaced in 1931 by one-man 900 Class streetcars. Car No. 956 is just outside Piedmont Station, which is being modernized in this 1937 view. (Randolph Brant collection.)

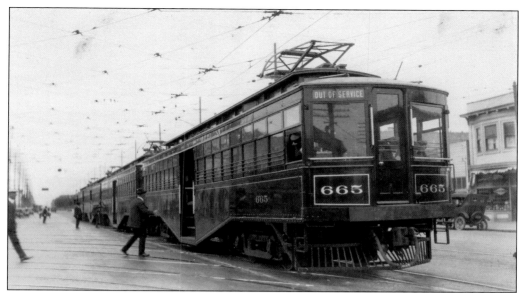

The father-son relationship between the Key's 1917 650 Class low-floor, wide-door, center-entrance cars and the bridge units of the 1930s is easily discerned by studying the configuration of No. 665. This relationship was reinforced in 1931 when the Emeryville Shops created a single articulated car out of two 650s. Note that the Key Route offered its famous rail fan seat before there were rail fans. In 1923, No. 665 at the Elmhurst car house leads a special train bound for Hayward and San Leandro in celebration of two new ferryboats named after those cities. (Randolph Brant collection.)

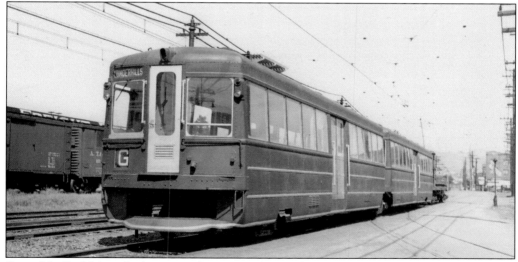

One of the Bethlehem-built units in the series 165–187, after arriving at the Santa Fe Railroad–Key System interchange in 1937, is being towed through the Yerba Buena Yards on its way to the Emeryville Shops. At the Key shops, the unit will receive all additional necessary parts to enter revenue service, including a used pantograph. The new bridge units would not be without their critics, however. Some criticized on subjective aesthetic grounds. All who would ride on hot days criticized the ventilation, which initially consisted of opening the end-train doors. (Walter Rice collection.)

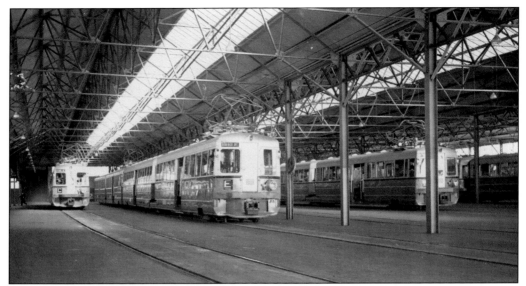

Bridge unit devotees will immediately notice why these units at the pier in 1937 are different. The highlights are mounted, as the designers originally intended for daylight operation, under the passenger window, but even more striking are the solid train doors. Both these design "errors" were soon corrected. Highlights were permanently placed on the train doors and windows for visibility, and ventilation was also added to the doors. (Randolph Brant collection.)

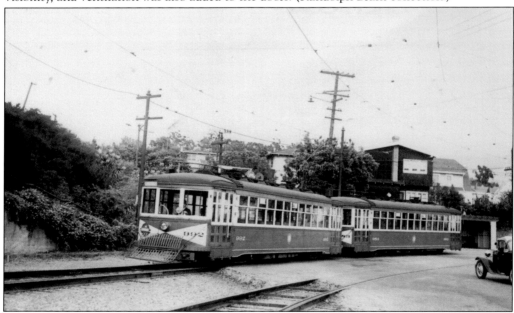

Before the 1939 opening of the Bridge Railway, the curves east of the Piedmont Station were realigned to accommodate Oakland Avenue routing for the new bridge units. During this 1938 construction, all service was provided by connecting shuttles. Since only one of the regular shuttle cars—either No. 955 or No. 956—was needed for the G-Westbrae Shuttle and two cars were needed for peak periods, Car No. 992 and Car No. 983 were selected for this temporary service. (Randolph Brant collection.)

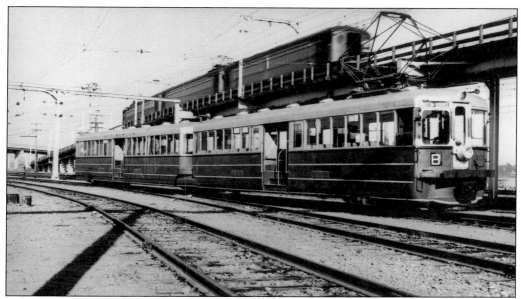

Unit No. 101, one of four (Nos. 101–104) built in 1937–1938 in Key's Emeryville Shops sporting the silver and orange below paint scheme, is posing for the company photographer as a Southern Pacific Interurban Electric three-car train passes overhead. Perhaps Key's president, Alfred J. Lundberg, has decided to show off the handsome new Key transbay equipment by comparing it to the 1911 cars of his rival. (Walter Rice collection.)

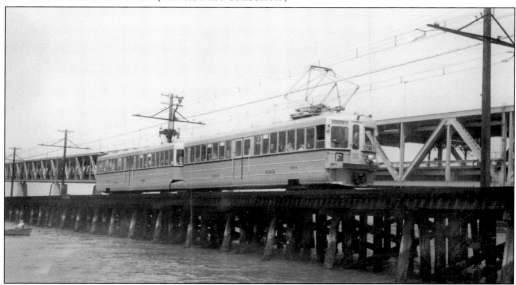

After departing from the pier, Unit No. 104 shows off its 110 feet, 5.5 inches in length as it speeds on the pier trestle toward land in 1938. Unit No. 104 and three other Key System–built units were the heaviest of all the bridge units, at nearly 148,000 pounds. A charge against all of the Lundberg bridge units was that they were underpowered. This is true. But an examination of the Key routes, including the Bay Bridge where the motorman's speeds were governed to a maximum of 35 miles per hour, indicates that the heavy bridge units should not have been running rapidly anywhere they went. (Walter Rice collection.)

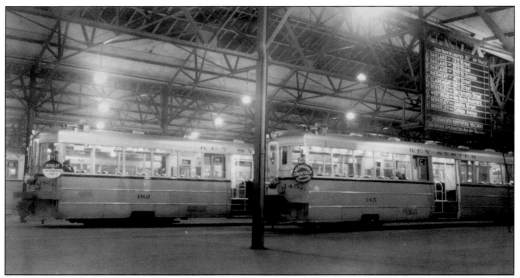

The bridge units rule, and the 500s and 650s are history. Returning from the San Francisco Eastshore Empire in 1938, residents were greeted at the pier by a lineup of sparkling new orange and silver Key trains. Disks direct riders to their correct train. (Walter Rice collection.)

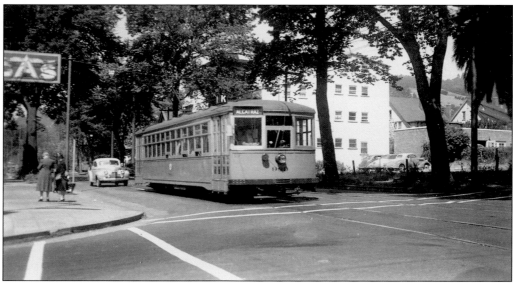

Until the 1941 free transfers between Key's transbay lines, local East Bay lines were not issued. As part of its competitive strategy against SP's red electrics in south Berkeley, the Alcatraz–College Avenue line was made part of Key's transbay system. Here, in 1938, Car No. 980 heads south on College Avenue toward a timed transfer with the F-train. Single cars operated during off-peak hours and two-car trains during peak periods. (Randolph Brant collection.)

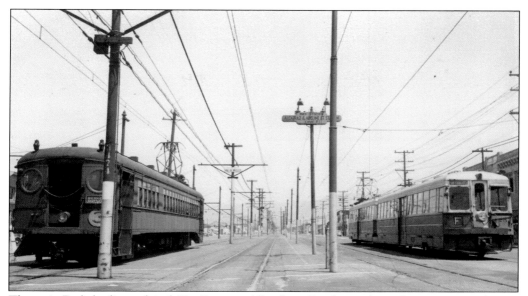

The main Berkeley lines of rivals Key Route and Southern Pacific ran down the same street. As part of a larger 1933 plan to eliminate duplication, Key abandoned its Berkeley line north of Alcatraz Avenue, where F-train Unit No. 125 is laying over in 1939. Within two years, competition and rivalry would become a distant memory as Southern Pacific would totally abandon its Eastshore Empire electric lines. (Randolph Brant collection.)

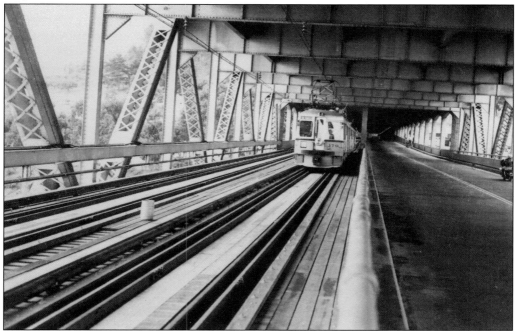

Unit No. 179 has the privilege of testing the Bridge Railway. The third rail for Key trains had yet to be energized in September 1938. With its pantograph up, Unit No. 179 is drawing its 600 volts from the overhead wire, which soon will flow with 1,200 volts for Interurban Electric and Sacramento Northern trains. (Randolph Brant collection.)

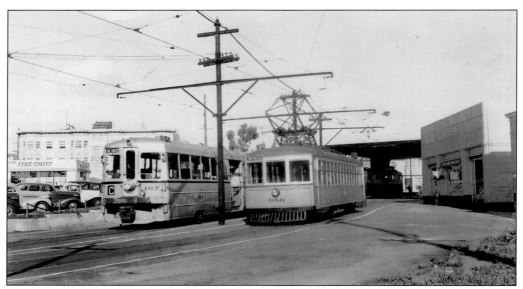

The year is 1938, and the 650 Class cars are just about gone. Since the new bridge units could not use the trackage east of the Piedmont Station, streetcars were fitted with pantographs and ran as Key shuttles, which connected at Piedmont Depot with pier trains. On January 15, 1939, concurrent with the opening of the Bridge Railway, bridge units ran directly to Piedmont's Oakland Avenue. Key had rebuilt the curves allowing the bridge units to clear. (Randolph Brant collection.)

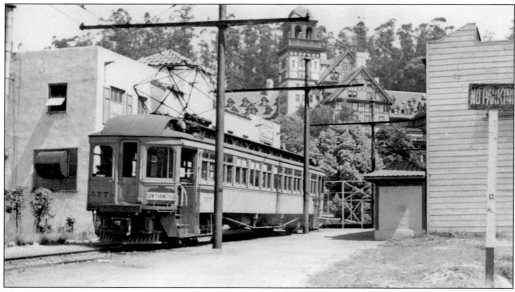

Nearing its final mile, Car No. 577 still looks good and serviceable. However, progress is at hand with the soon-to-arrive bridge units. The Claremont Hotel, a project of Borax Smith, was said to be a Key property that "made good." (Photograph by Wilbur C. Whittaker; Walter Rice collection.)

Where are the words "Key System?" Not on Unit No. 183, which is outbound to Underhills on the Grand Avenue segment of the B-train in 1937. No. 183 is undoubtedly a recent arrival from Bethlehem's Wilmington, Delaware, factory, and Key is in such a rush to enter it into revenue service that the Emeryville Shops have yet to apply the company name. (Walter Rice collection.)

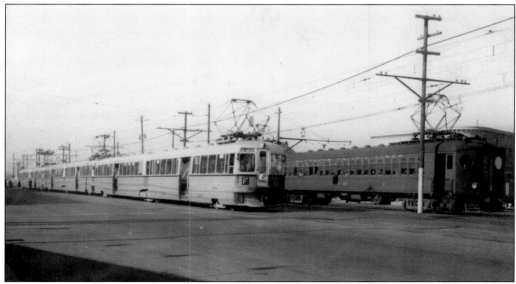

Even after the 1933 reductions in Key and Southern Pacific redundant service, head-to-head wasteful competition still existed. A reasonably full red train from Northbrae and central Berkeley has arrived at Alcatraz Avenue and Adeline Street, where Key's F-train would soon commence its journey. The competitors would now use parallel trackage and riders of both companies would arrive at San Francisco's Ferry Building (Walter Rice collection.)

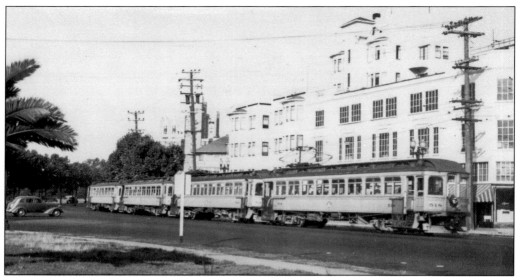

In two years, these 1937 Lakeshore Boulevard B-train commuters would have a one-seat ride directly into San Francisco. The 500s were replaced by "modern" bridge units, and the trestle, pier, and ferry trip likewise would be a memory. Importantly, it was the Toll Bridge Authority, not Key, who would build and maintain the Bridge Railway and its supportive facilities, including San Francisco's Transbay Terminal. Key therefore would no longer have the maintenance costs for its fill, trestle, and ferry pier, and would relinquish the ferry business as well. (Walter Rice collection.)

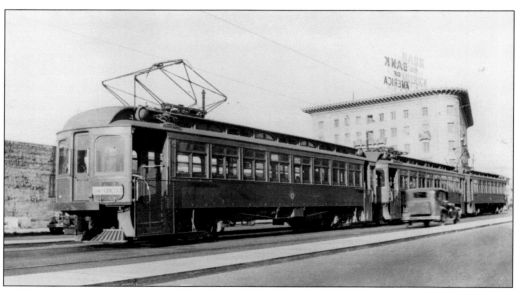

A three-car train of classic, solid orange 500s is stopped on Grand Avenue at Broadway for riders, which appear to be few, if any. It is the Depression year of 1935, and the economy is in a trough. Soon the 500s will be rumbling along Grand Avenue intimidating motorists. (Walter Rice collection.)

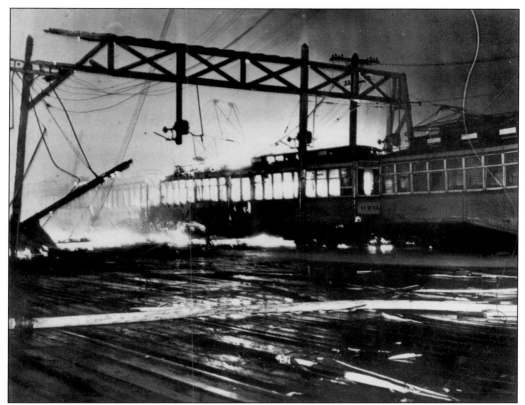

A disastrous pier fire occurred on May 6, 1933, and several cars, the ferry *Peralta*, and the terminal were destroyed. Now, in addition to planning the Bridge Railway, Key had to scramble to provide resources to resume service. It would be many months before service would reach prefire levels. (AC Transit collection.)

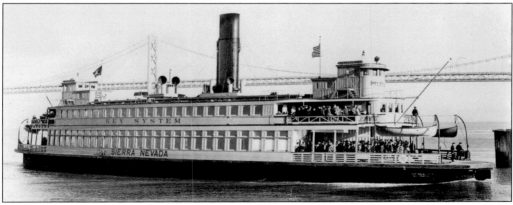

The ferry *Sierra Nevada* served Key System briefly for the 1939–1940 fair. A real "Boomer," it was built in 1913 for the Western Pacific Railroad. It was then transferred to SP's Alameda service, where it ran until January 1939. After its stint with the fair, it was drafted by the army for service in World War II. Following the war, she was picked up by Richmond-San Rafael Ferry. When that line shut down in 1956, she became a floating store in Southern California, where she sank in a storm in 1977. (Walter Rice collection.)

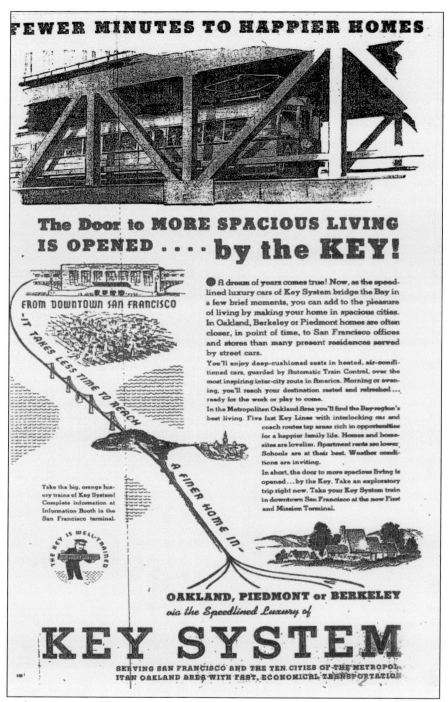

"Spacious living, gracious luxury" were the appeal of the Eastshore Empire in prewar days. It would prove to be the last gasp of East Bay boosterism. The war and a long postwar decline would dim the luster of Oakland's crown. Nevertheless, Key would fill newspapers with ads extolling the virtues of living and doing business in the Eastshore Empire. (Val Lupiz collection.)

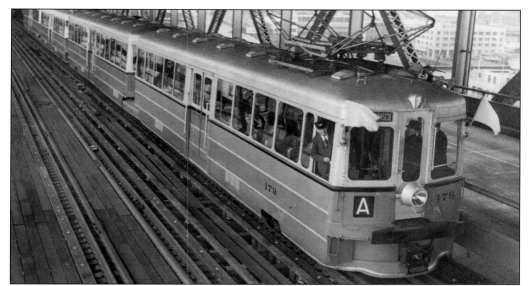

The State of California's heavy involvement in the building of the Bridge Railway was benchmarked by the fact that the "motorman" on the September 16, 1938, ceremonial test train was California governor Frank Merriam. Under the Bridge Railway Agreement of March 6, 1936, for a levy of 2.5¢ per transbay passenger (transbay fare was 21¢) and deeding units 150–187 to the Toll Bridge Authority for Key's share of the cost of making its rolling stock compatible for the Bridge Railway, Key System got to run its trains over the Toll Bridge Authority's tracks. Here it's historical portrait time as motorman Merriam has halted the ceremonial special near the San Francisco end of the railway for the occasion. (Caltrans.)

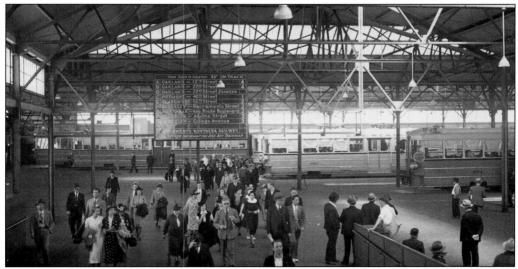

San Francisco–bound office workers at the Key Pier are streaming from their new bridge units to catch the next ferry in 1938. It is a hot spell since bridge units not needed until the afternoon rush hour have their shades drawn to shield against the heat of the sun. The new silver and orange units, Nos. 100–124, had small windows with straight-lined bodies, and units 125–187 featured slanted sides with wider windows. Within the group of 88, there were many variations, most not visible to the casual observer. (Paul Trimble collection.)

Another Dream Comes True!

By Bill O'Malle[y]

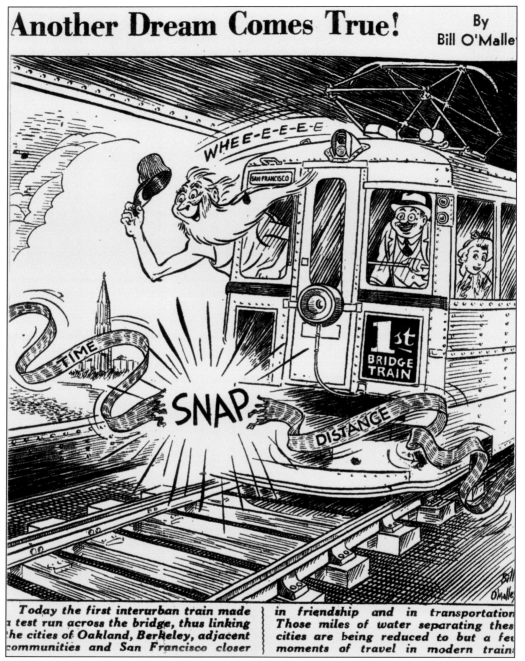

WHEE-E-E-E-E

SAN FRANCISCO

TIME

SNAP

DISTANCE

1st BRIDGE TRAIN

Today the first interurban train made a test run across the bridge, thus linking the cities of Oakland, Berkeley, adjacent communities and San Francisco closer in friendship and in transportation. Those miles of water separating these cities are being reduced to but a few moments of travel in modern train[s]

Father Time was featured in the *Call-Bulletin*'s September 1938 cartoon by Bill O'Malley ,which celebrated the first bridge test train. "The cities of Oakland, Berkeley and adjacent communities and San Francisco are now closer in friendship and transportation. Those miles of water separating these cities are being reduced to but a few moments of travel in modern trains." (Val Lupiz collection.)

Five

THE BOOM YEARS
OF WORLD WAR II

In anticipation of the Bridge Railway, Key System began using a system of letters to designate their transbay lines, which were clearly displayed on the ends of the new units. The new route designations were:

A: Twelfth Street–Oakland
C: Fortieth Street–Piedmont
F: Berkeley
H: Sacramento Street–Northbrae
X: Exposition (inbound to Key Pier, 1939)

B: Twenty-second Street–Grand Avenue
E: Fifty-fifth Street–Claremont Avenue
G: Westbrae Shuttle
K: Alcatraz–College Avenue Shuttle*
* *At various times designated L, G, and 31 also.*

The missing and never used "D" had been set aside, as early as 1934, for a transbay Montclair line over the trackage of the Sacramento Northern Railway. Southern Pacific, organized as the Interurban Electric Railway (IER), had assigned numbers to their lines since December 1, 1938. The Bridge Railway proved not to be the hoped-for boon to ridership. In 1941, the Bridge Railway companies carried 30 percent less business than two years before. During February 1940, the IER asked the California Railroad Commission for permission to totally abandon all its routes.

On January 18, 1941, Key began running buses in lieu of IER's Alameda lines. On March 22, IER's Seventh Street to East Oakland and San Leandro line was replaced by an extension of the A-train, which went first to East Fourteenth Street and 105th Avenue and later to Havenscourt beginning on April 3. Rush-hour trains that still terminated at Third Avenue and East Eighteenth Street were now designated A-1.

On July 26, 1941, Berkeley lost four rail lines—Shattuck Avenue and Ninth Street (the last two IER lines), the weak H (Sacramento Street), and the G (Westbrae shuttle). The F-line was extended from Alcatraz Avenue and Adeline Street via Shattuck Avenue to University. It was subsequently extended via former IER track to Solano Avenue in Thousand Oaks.

In less than six month after the departure of the IER, the United States became involved in World War II. Gas and rubber rationing were put in place. What was the result? Key's ridership suddenly and dramatically boomed.

In January 1941, Henry J. Kaiser opened a huge shipyard complex in an isolated area of Richmond. After the country entered the war, its location became a major concern because of gas rationing. On June 6, 1942, the Maritime Commission announced the Key System would build and operate what became known as the Shipyard Railway.

The symbol of the Shipyard Railway, which began revenue service on January 18, 1943, was the ancient, wooden, late–19th century New York City elevated cars. From Emeryville, the Shipyard Railway used a combination of existing streetcar trackage, abandoned tracks of IER's Ninth Street line, and new alignments to reach the shipyards. Service ceased on September 30, 1945, shortly after the war ended. The Maritime Commission offered the line to Key System. Without hesitation, President Lundberg said, "No." It would lose money.

The surge in wartime economic activity saw transbay rail ridership jump from more than nine million passengers in 1940 to nearly 26.5 million in 1945. These were the boom years for the Key's Eastshore Empire transbay lines.

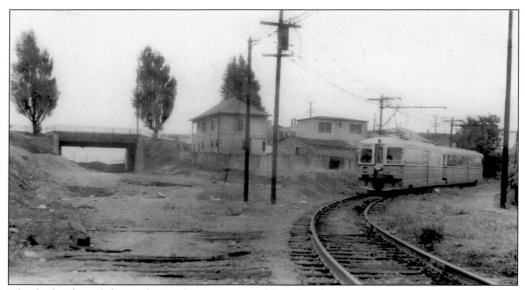

The lack of a solid population base was a problem for the H–Sacramento Street line. The Sacramento Street line opened in 1911 to create real estate opportunities for Borax Smith and Associates. This 1939 photograph attests to the fact the early real estate barons were disappointed. Here Unit No. 116 is on Monterey Avenue. (Walter Rice collection.)

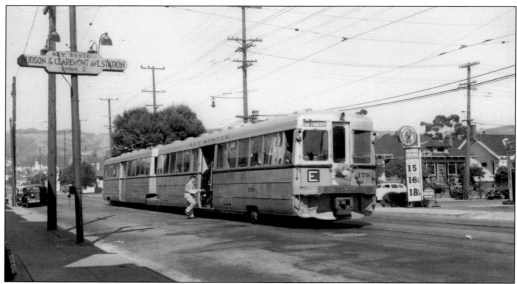

Key's competition—the automobile—can be filled up for 15¢ a gallon at the local Mohawk gas station, seen here on September 2, 1941. Neither those who drive automobiles nor those who are boarding the E-train passengers at Hudson and Claremont Avenue Station are aware that in a little over three months Japan will attack Pearl Harbor. Gasoline soon would be rationed and Key's ridership would boom. (Will Whittaker photograph.)

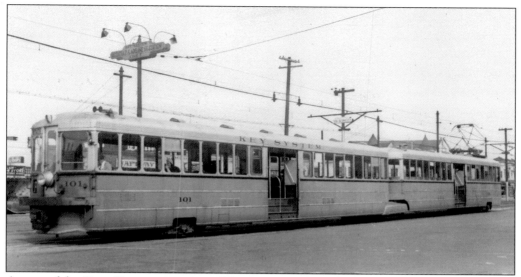

As part of the Great Depression policy of Key System and Southern Pacific to eliminate transbay duplication, Key abandoned its Berkeley line north of Alcatraz Avenue. Unit No. 101 is awaiting its starting time for another F-line journey into San Francisco from this cut-back point in South Berkeley. (Walter Rice collection.)

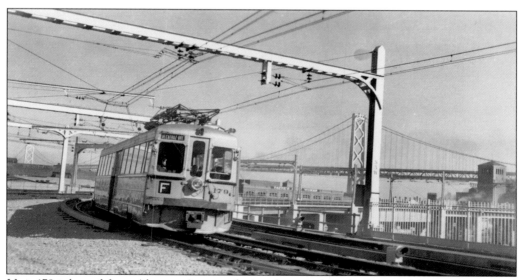

Unit 179 inbound from Alcatraz Avenue, during the era when the F-train did not serve central Berkeley, has crossed the San Francisco-Oakland Bay Bridge (in the background) and is about to enter its final stop at San Francisco's East Bay Terminal in 1940. On the Bay Bridge and in the San Francisco terminal zone, Key trains ran with the pantograph down since they drew their 600 volts of electricity from the third rail. The overhead wire was energized with 1,200 volts for Interurban Electric and Sacramento Northern trains. (Walter Rice collection.)

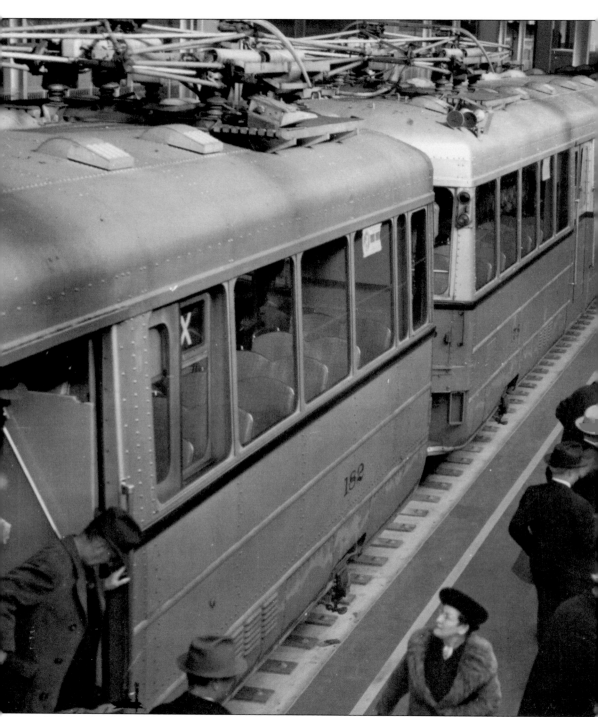

It is the day before the "Brave New World" of the Bridge Railway, January 14, 1939. Throngs of the Eastshore Empire's VIPs and the curious have arrived at San Francisco's brand-new six-track East Bay Terminal building on two maximum-length, seven-unit trains to witness the formal

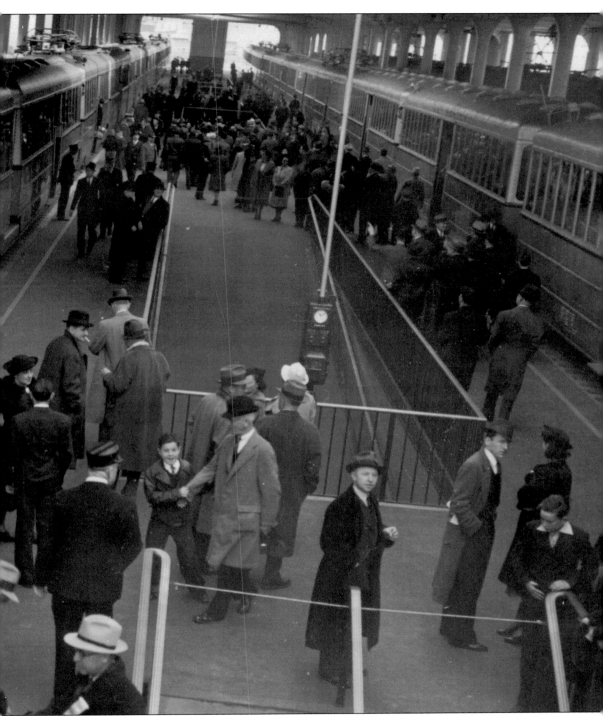

dedication of the new transit facility. Sacramento Northern ran a six-car special from Chico, but Southern Pacific did not participate. (Emiliano Echeverria collection.)

Commuter Rush to Bridge Terminal Paralyzes Street Car Service

The first Monday of the Bridge Railway, January 16, 1939, created significant operational delays for all three Bridge Railway companies—Key System, Interurban Electric, and Sacramento Northern—because schedules that appeared practical on paper proved unworkable in reality. San Francisco's Market Street had similar difficulties. This was a front-page story for the readers of the *Call-Bulletin*. (Emiliano Echeverria collection.)

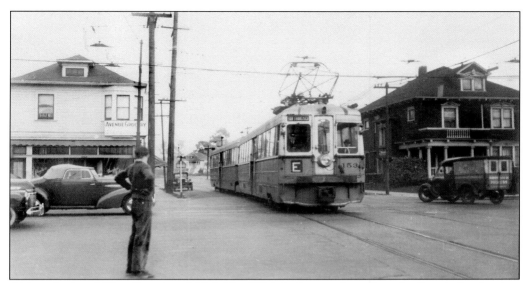

Although signed "San Francisco," Unit No. 153 is in fact eastbound on the E-train having just turned off Claremont Avenue onto Domingo Avenue, where No. 153 is crossing Ashby Avenue just before terminating adjacent to the Claremont Hotel's tennis courts in 1939. (Photograph by Ken Kidder; E. R. Mohr collection.)

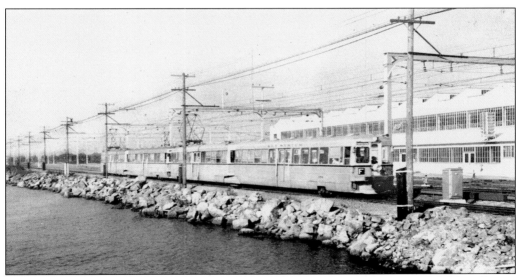

Headed by Unit No. 179, a two-unit F-train, bound only for Alcatraz Avenue and Adeline Street, passes by the Bridge Yard's shop building in 1940. After economy-minded, anti-rail National City Lines management closed and sold the Emeryville Shops in the 1950s, this facility became Key's last rail equipment maintenance shop. (Randolph Brant collection.)

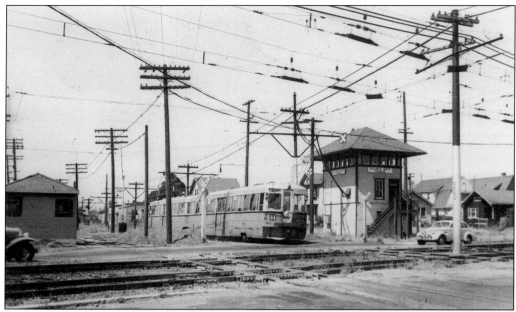

The modern design of the H-train's Unit No. 150 clashes with its surroundings, including the grey sedan, the latest from General Motors. At Golden Gate Tower, Unit No. 150 is crossing the tracks of rival Interurban Electric Railway's line to central Berkeley and Thousand Oaks in 1940. The wigwag signal has protected the occupant in the front rail fan seat from having a memorable adventure with the grey sedan. The H-line was converted to buses in 1941; the units were needed elsewhere because of IER's departure. (Randolph Brant collection.)

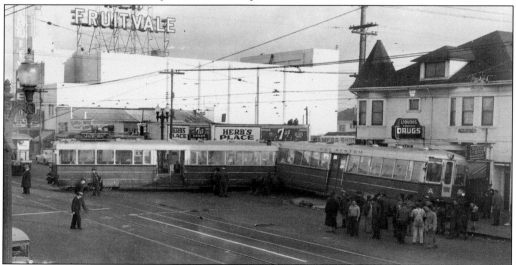

In 1941, the A-line was extended from central Oakland south to Havenscourt. A rookie A-train motorman, who failed to see the switch, was set for Thirty-eighth Avenue No. 11 streetcars when he accelerated straight across Thirty-eighth Avenue, derailing the train. Passengers who thought they were going to San Francisco instead of Thirty-eighth Avenue are clustered at the end of the derailed unit as Key officials take names and offer alternative transportation. (John F. Bromley collection.)

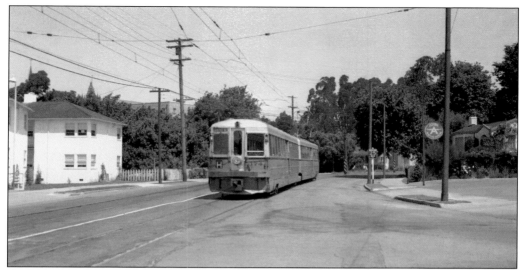

As part of the March 1933 program to eliminate duplication, the outer end of Key's Sacramento Street Northbrae line was rerouted to Monterey and Colusa Avenues over SP's now abandoned and parallel California Street line. Nevertheless, the H-Sacramento Street transbay line was Key's weakest. During 1939, the H only carried a little over 4,000 weekday riders. Here outbound Unit No. 174 is nearing the Colusa Avenue terminal in 1941. (John F. Bromley collection.)

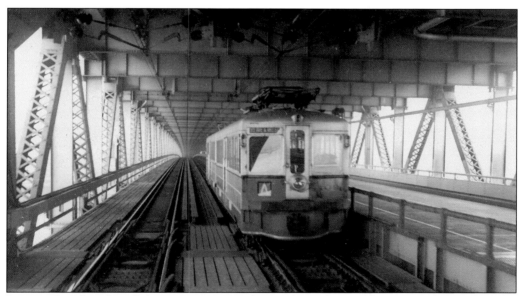

Just another day aboard the "most scenic railway ride in the world," or so said the ads. Who could argue? Commuters had an unmatched view of the bay and its environs, all of which was invisible to the automobile driver. Only the old-time ferry riders said they had it better. (Walter Rice collection.)

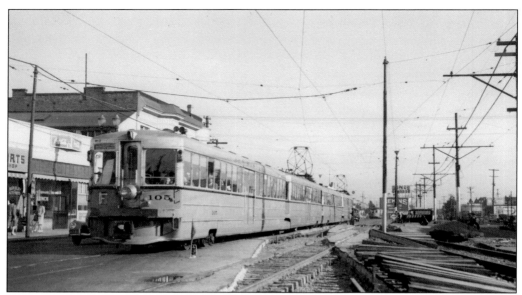

When Key System took over for the abandoned Southern Pacific Interurban Electric lines, the F-train was extended temporarily from Alcatraz Avenue and Adeline Street to its traditional Shattuck Square terminal. The goal was to reach Berryman, Northbrae, and Thousand Oaks. In order to achieve this goal, F-trains had to switch from Key trackage to ex-IER tracks. This August 1941 photograph shows the construction of this connection at Dwight Way and Shattuck. (Walter Rice collection.)

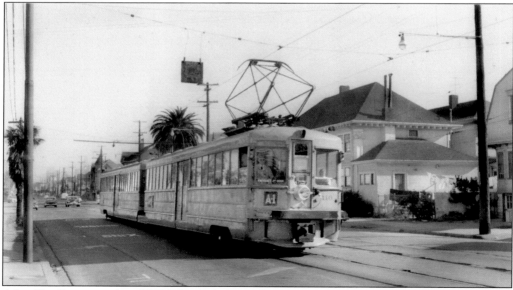

After Key System replaced IER's Seventh Street line in March 1941 with the combination of an A-train's southward extension and a new bus routing, trains continued to terminate at the A-line's former terminal at Third Avenue and East Eighteenth Street until 1946. These short turns were designated A-1. In 1957, Unit No. 110, signed for this former routing, is in fact heading for the A-line's post-1950 terminal at Twelfth and Fallon Streets. (Walter Rice collection.)

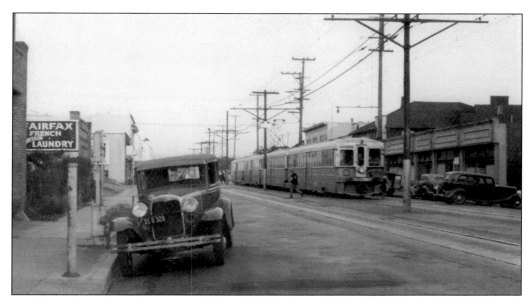

Unit No. 136 and its mate are inbound from Havenscourt on former IER trackage at Bond Street and Fairfax Avenue in 1941. The signage implies that the train is heading for a Bridge Yard tie-up for the night. The evening rush hour is over. (Walter Rice collection.)

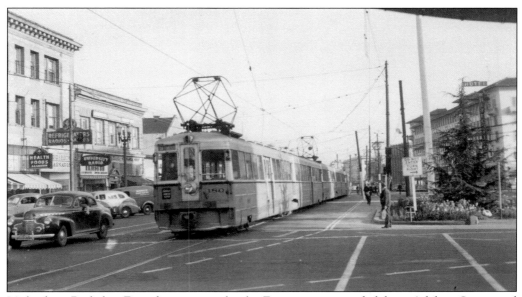

It's back to Berkeley. Four days previously, the F-train was extended from Adeline Street and Alcatraz Avenue back to central Berkeley. The once-rival Southern Pacific enthusiastically had ceded all suburban Eastshore Empire transbay service to Key System. Here Unit No. 180 trails a mate as it passes through a classic 1940s shopping district—Shattuck and Central—on July 31, 1941. (Photograph by Ken Kidder.)

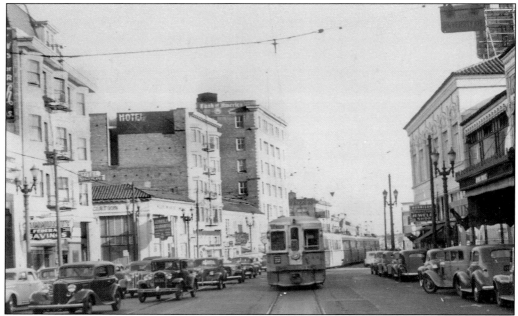

Looking south, an F-train is leaving for another trip to San Francisco across the Bay Bridge. It was the summer of 1941, and the Key's F-line has just been extended back to Berkeley's Shattuck Square. However, very soon, F-trains would extend along former IER (SP) trackage to the Northbrae Tunnel and later through the tunnel to Thousand Oaks. (Photograph by Ken Kidder; E. R. Mohr collection.)

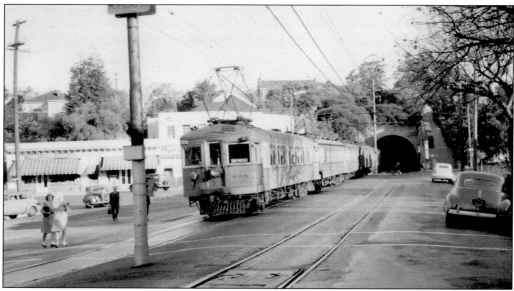

In March 1942, Key rescued five former Sacramento Northern cars (the SN had discontinued all passenger service in June 1941) from a scrap dealer, refurbished the cars, and placed them into service on the F-Berkeley line, where they were soon called the "City of Berkeley." They ran until 1949. One of the former SN cars, No. 1005, is currently (2006) being completely rebuilt at the Western Railway Museum. (Photograph by Ken Kidder; E. R. Mohr collection.)

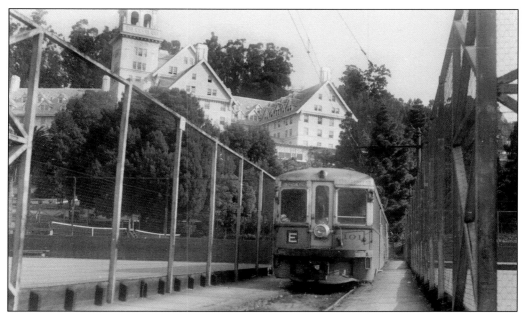

Borax Smith built his grand Claremont Hotel at the foot of the Oakland/Berkeley hills, the end of his transbay Fifty-fifth Street–Claremont Avenue line. By December 18, 1942, when Unit No. 101 (on the now-designated "E") was resting between the Claremont's tennis courts, Smith was but a faded memory. (Photograph by Ken Kidder.)

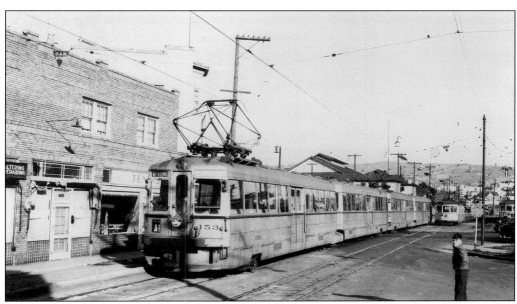

The A-1 line, created in 1941, used the routing of the prior A–Twelfth Street line to the Central car house. In 1941, a new A-line was created because of the end of Interurban Electric's Seventh Street line. The new A was extended first to San Leandro and ultimately to Havenscourt. The A-1 was a short turn of the revised A-line. In 1946, the A-1 line was discontinued. (Mike Anderson collection.)

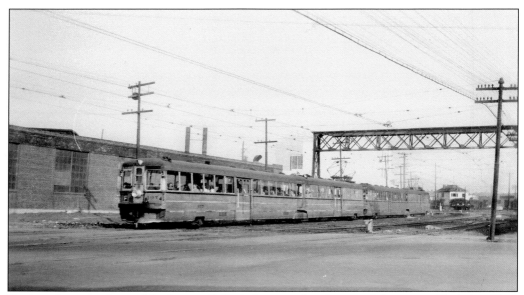

Passing the unused signal bridge, an F–Berkeley train heads toward downtown Berkeley. Here wartime grey roof paint is evident, designed to cut down the units' visibility from the air in the event of an enemy attack. At war's end, Key's otherwise handsome bridge units looked ragged. (Photograph by Ken Kidder; E. R. Mohr collection.)

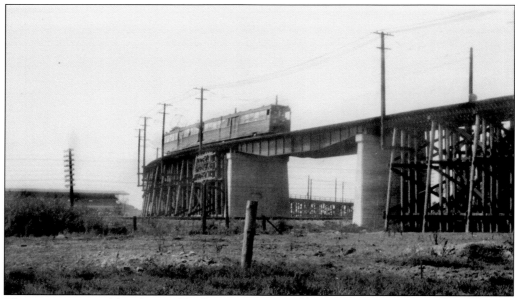

The construction of the Shipyard Railway resulted in California's biggest railway scavenger hunt. In Albany, the Shipyard Railway line had to cross the busy Southern Pacific Railroad mainline, and in order to create a safe crossing, the Shipyard line was elevated. Steel girders proved to be unavailable for the bridge. Instead, two surplus Southern Pacific turntables (one for each direction) were placed in the concrete abutments. Here an all–local stops bridge unit safely crosses over the mainline railroad tracks in 1943. (Randolph Brant collection.)

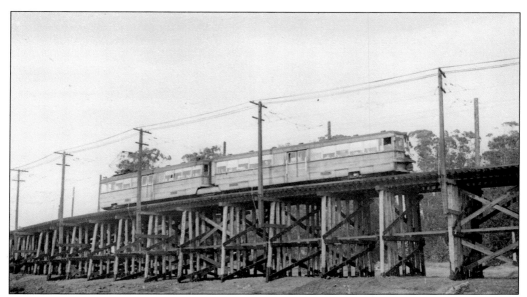

Alfred J. Lundberg would have been stunned if he looked into a crystal ball on March 25, 1933, the last day of Southern Pacific's Ninth Street line, and saw that less than a decade later his new bridge units would be trundling down Ninth Street on a northward journey to Richmond. Yet, this is exactly what occurred. Here Unit No. 127 is ascending the Albany Shipyard Railway trestle. (Randolph Brant collection.)

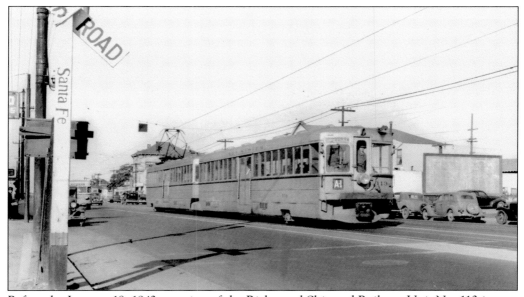

Before the January 18, 1943, opening of the Richmond Shipyard Railway, Unit No. 113 is on a test run on San Pablo Avenue at Park Street in Emeryville. Initially, all the ex-El cars lacked steps, and their only passenger points were the line's high-platform terminal stations. The ex-El cars ran express service, while bridge units undertook local service. In addition, Key ran a bridge-unit shuttle service from the end of the A-1 line at Third Avenue and Eighteenth Streets to the Oakland/Emeryville Shipyard Railway terminal station. (Walter Rice collection.)

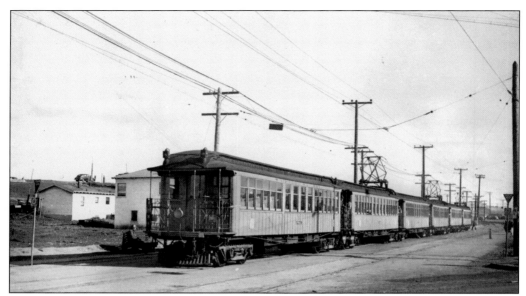

Owned by the U.S. Maritime Commission and operated by Key System, a set of six ancient New York El cars rumble down Richmond's Potrero Avenue in 1943 en route from Henry Kaiser's Richmond Shipyards to Fortieth and San Pablo and Poplar and Louise Streets stations. San Francisco workers could purchase a monthly San Francisco–Shipyards commute ticket for $7.75. Two of these unique California ex-El cars are nearing a complete restoration at Western Railway Museum as of 2006. (Randolph Brant collection.)

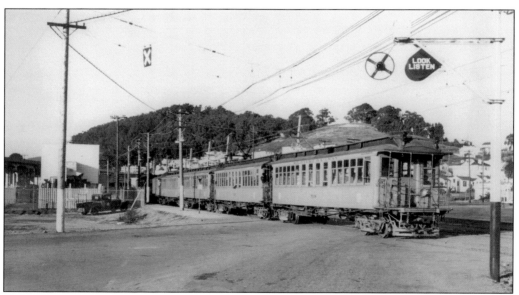

A six-car Shipyard Railway nonstop express train is crossing Albany's Buchanan Street in 1944. The wigwag signal is actively warning motorists of the danger these ancient, former New York City Second Avenue El cars present. Chances of a grade-crossing accident are minimal, however, since gasoline and rubber rationing have caused the street to be devoid of dangerous motor vehicles. (Randolph Brant collection.)

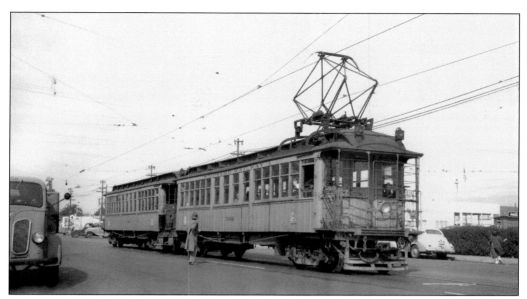

Semipermanently married Shipyard Railway Cars No. 548 and No. 546 are stopping for a local passenger on San Pablo Avenue at Ashby in June 1945. These two ex-El cars were some of the select few that had added steel folding steps to enable them to have local street stops, thus allowing all Shipyard bridge units to return to transbay service. (John F. Bromley collection.)

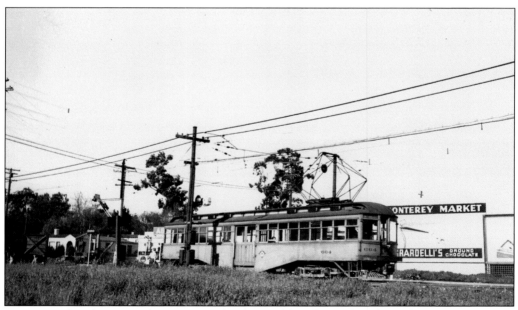

Two years after the September 30, 1945, shutdown of the Shipyard Railway, the No. 501, an 1887 product of Gilbert and Bush, has been spotted on the Santa Fe Railway's siding at Tehachapi, California. Many of the ex-New York City El car bodies became farm or ranch sheds, and some were even converted to bunkhouses. (Randolph Brant collection.)

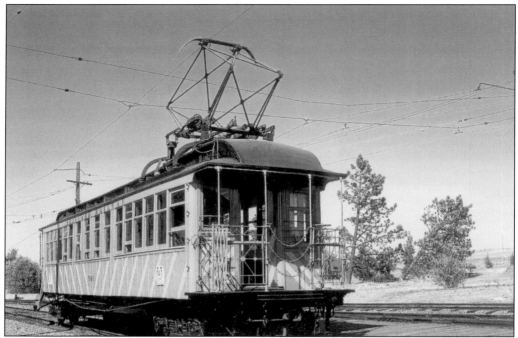

Today two former Shipyard Railway cars are at the Western Railway Museum, where the museum is currently rebuilding these classic 1888 open platform New York City railway coaches. In 2005, No. 561 shows off the museum's high level of craftsmanship entailed in the rebuilding—"Better than New." (Photograph by Walter Rice.)

Bridge Unit No. 127 is filling a local schedule on the Shipyard Railway. Here at Buchanan Street in Albany, a substation is visible behind the unit. The overpass of U.S. 40 (now I-80) is in the background. (Photograph by Ken Kidder; E. R. Mohr collection.)

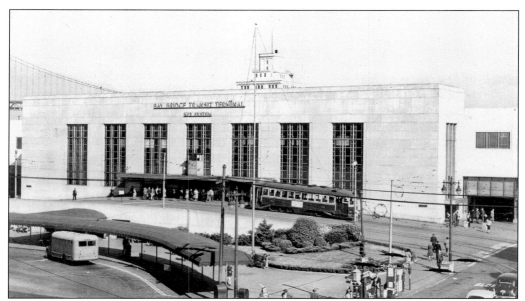

San Francisco Municipal streetcar No. 79 is about to pull up a few feet to load the many passengers that Key System trains have brought to the "Bridge Terminal" at First and Mission Streets in 1945. No. 79 is painted in the blue and yellow colors of the University of California, a major Key System traffic generator. Key trains arrived and departed from the terminal's third level, No. 79 is on the second ticketing level, and the waiting room is on the first level. (Randolph Brant collection.)

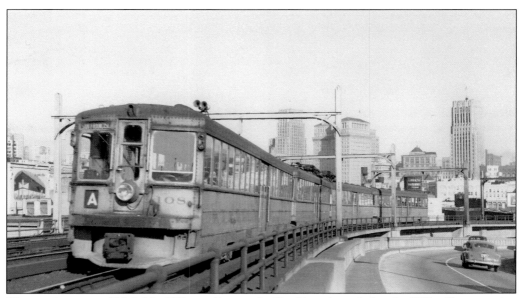

The war is over, and Unit No. 108 traveling on the San Francisco viaduct in 1947 will not receive back its prewar silver painted roof. The Key System has been purchased by National City Lines (NCL), and soon all of the units will bear the NCL's "fruit salad" color scheme—orange body, green window frames, and white (later tan) roof. (Walter Rice collection.)

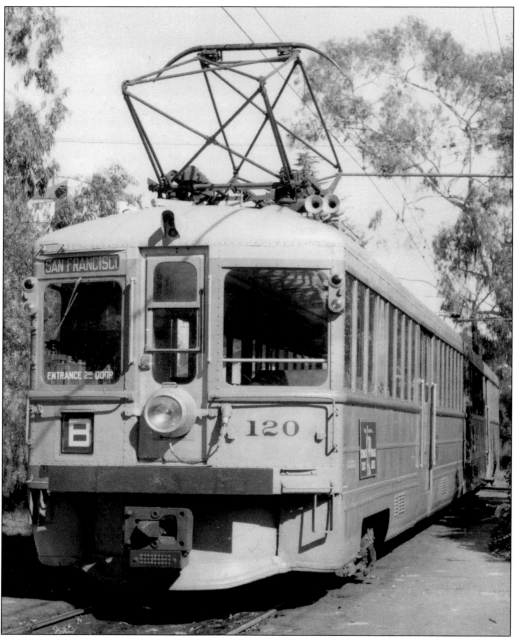

National City Lines purchased Key System and painted the bridge units in their company's paint scheme—the famous "fruit salad" colors. Now called Key System Transit Lines, the name itself bodes ill for the rail operation. It took a dozen years, but by the time National City Lines was done with Key System, the Key was an all-bus operation. This 1956 view was taken at the end of the B-line. (Walter Rice collection.)

Six

FROM RAIL TO RUBBER

The intense wartime use took a heavy toll on both cars and tracks, and adequate labor and materials for maintenance were in short supply. The boom produced dramatic postwar plans, and new, faster and lighter-weight bridge units were discussed.

The major postwar event was the sale of Key System by Lundberg and his associates to a subsidiary of National City Lines (NCL) on May 16, 1946. The new owners made it clear that trolley buses and modern Steamline streetcars were "impractical."

Lundberg's group made 600 percent profit on their stock shares. Lundberg undoubtedly realized that the boom of the war years was an aberration, and the downward slide would soon return. It did. National City Lines was interested in selling buses, oil products, and tires, primarily by replacing rail lines with buses. In the tradition of NCL properties, the company name changed to Key System Transit Lines and used the colorful "fruit salad" paint scheme of white, yellow, and green.

During 1948, the new NCL management completed the conversion of Key's streetcar lines to bus. In 1946, a small section of transbay trackage was abandoned when the A-1 and K lines were discontinued.

At the city's request, the first major change occurred on October 29, 1950, when the A-line was cut back to downtown Oakland on Twelfth and Fallon Streets. Key endorsed the proposal. The tenure of NCL was characterized by labor unrest, fare increases, demographic changes that shifted ridership away from Key's transbay lines, and service reduction such as in 1954 when buses replaced trains on the C and E lines, nights, Sundays, and holidays. The flight to the suburbs was in full swing, and the automobile was becoming the mode of choice. In 1957, the last full year of transbay rail service, 5.2 million passengers were carried, or only 15 percent of the 1945 total.

The words "retrench" and "defer" characterized the Key System in the 1950s. From 1952 forward, unneeded units were withdrawn from service, stored, and offered for sale. Track deterioration was common, and sections of it rose out of the street from the weight of a unit. The California Public Utilities Commission issued slow orders throughout the system. The only question was when would the end come?

Finally, Key had a formidable ally on its side—the State of California, who wanted to convert the right-of-way of the Bridge Railway for motor vehicles. Key would incur no costs for the conversion. Key now moved, with the backing of most local politicians and the Bay Area press, to end transbay train service.

In the early morning hours of April 20, 1958, the last bridge train left San Francisco on the A-line. Drunken sailors returning to the Treasure Island Naval Base joined the rail fans. The sailors' brains were too befogged to comprehend that this was an historic moment.

The bridge trains were replaced by 21 new diesel buses and 60 obsolete out-of-service gasoline-powered White coaches. Soon, however, on October 1, 1960, Key System ceased plying the streets of the Eastshore Empire. The Alameda-Contra Costa Transit District (AC Transit) now operated the all-bus transbay service.

The major postwar event was the sale by Alfred J. Lundberg and his associates of Key System on May 16, 1946, to a subsidiary of National City Lines. President Lundberg had guided the fortunes of Key System since the late 1920s. His goal was to ensure Key's financial value, often by productivity increases, such as the development of the labor-saving articulated bridge unit. Lundberg's tenure saw the successful transit operation set against war and the Depression. (Harre Demorro collection.)

What better way to catch the public's attention of a major change in phone numbers than with two clearly recognizable icons—the famous cartoon rabbit Bugs Bunny and a Key Route bridge unit. The immediate postwar period was an era when the Eastshore Empire's "trademark" was Key's transbay cars. (Val Lupiz collection.)

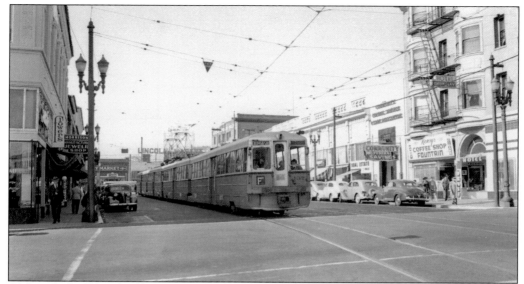

Although the F-line had been extended to Thousand Oaks after the 1941 end of the Interurban Electric Railway, ridership in 1947 was still heavy enough for Key System to short-turn certain F schedules at Shattuck Square—Shattuck and University. Unit Nos. 137 and 161 have their doors open, waiting for San Francisco passengers to board. (John F. Bromley collection.)

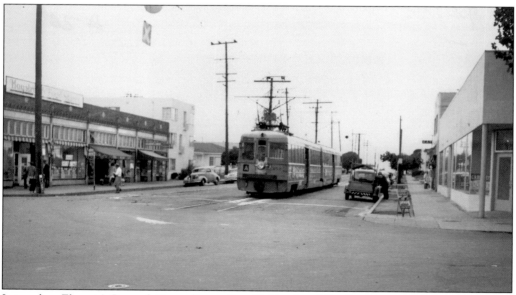

Interurban Electric's Seventh Street line to East Oakland and San Leandro was replaced in March 1941 by an extension south from central Oakland of Key's A-line. As of April 3 of that year, the A-trains tied up at Havenscourt Boulevard and Bancroft Avenue, where Unit No. 152 is seen here on its last day of service on October 29, 1950. The next day, A-trains would end in central Oakland at Twelfth and Fallon Streets, and Havenscourt riders would board a brand-new General Motors bus on the newly created transbay K motor coach line. (Walter Rice Collection.)

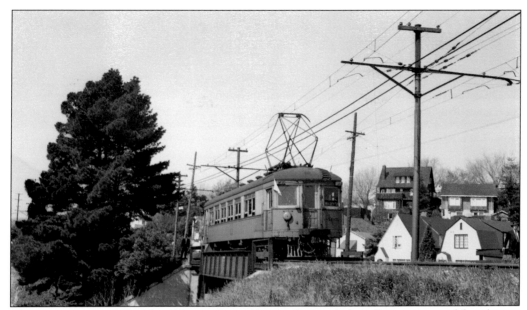

The war is over, and Key No. 495, as indicated by the flying of white flags, is on a rail fan charter in familiar F-line territory on the bridge over Berryman Street. On the F-line, No. 495 and four other ex-Sacramento Northern cars ran rush-hour service as the "City of Berkeley" from the end of 1942 until 1949. (John F. Bromley collection.)

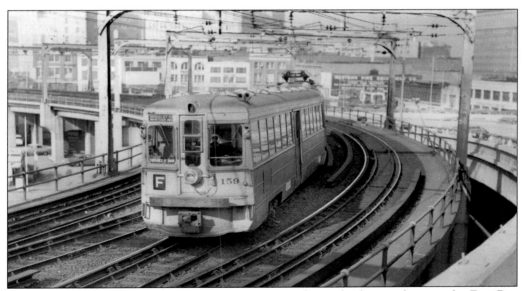

F-train Unit No. 159 is on the San Francisco terminal zone lead-in trackage to the East Bay Terminal on December 29, 1956. The number of tracks have multiplied from a single inbound to four tracks at this point, and soon it will increase to six. This photographer undoubtedly was in San Francisco since this was the last day of Geary Street streetcar and side-grip (as opposed to bottom-grip) cable cars. Within 16 months, Key's transbay rail operation would become a memory like that of the Geary Street streetcar. (Will Whittaker photograph.)

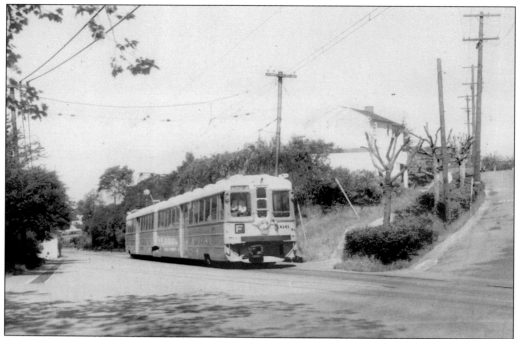

Unit No. 116, inbound from Thousand Oaks, rumbles along former IER trackage at Henry and Sutter in 1947. Soon this F-train will be boarded by multitudes in central Berkeley heading to downtown San Francisco, many of whom will be students and faculty of the University of California, Berkeley—a major Key Route traffic generator. (Photograph by Ken Kidder.)

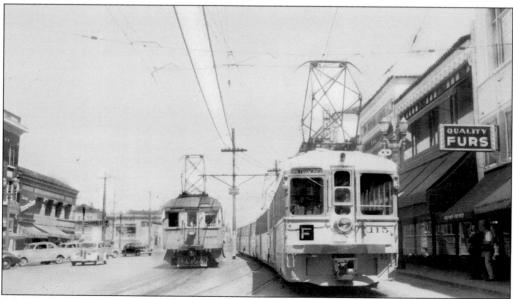

Although No. 115 is signed "San Francisco," it is heading toward the Northbrae Tunnel and Thousand Oaks. The real excitement is aboard the rail fan extra ex-Sacramento Northern Hall Scott Motor No. 499, at University and Shattuck in 1947. (John F. Bromley collection.)

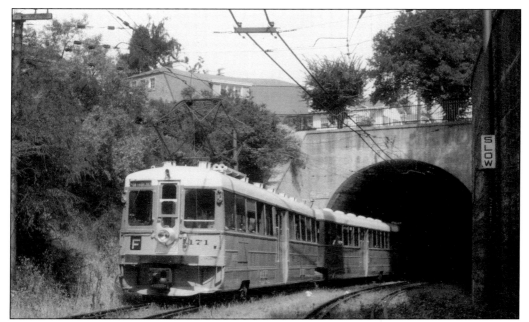

In various Bay Area newspapers on Saturday, January 14, 1939, the day before the opening of the Bridge Railway, Key System advertised its new cars were "air conditioned;" a claim totally without foundation. A solution for hot days initially consisted of opening the end-train doors. Later, vertically sliding glass panels were installed in these doors. Since 171's vertical panels are down as this F-train exits the Northbrae Tunnel in 1947, the weather must be hot. However, upon arrival in San Francisco, the temperature may be 30 degrees cooler. (Photograph by Ken Kidder.)

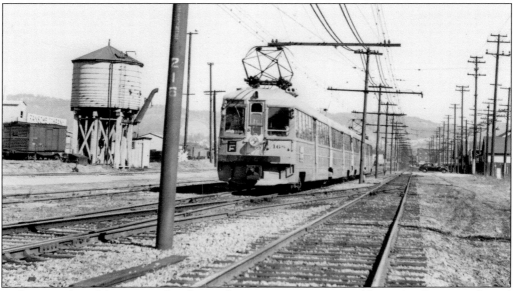

A classic artifact of the steam railroad era—the water tower—is noticeable as a San Francisco–bound F-train, led by Unit No. 168, speeds past the Santa Fe Railroad's Yerba Buena Emeryville freight yard in 1947. Unit No. 168 was one of a series of units numbered 165–187 that were built new, except for the pantograph, by Bethlehem Steel Company in 1937. (Randolph Brant collection.)

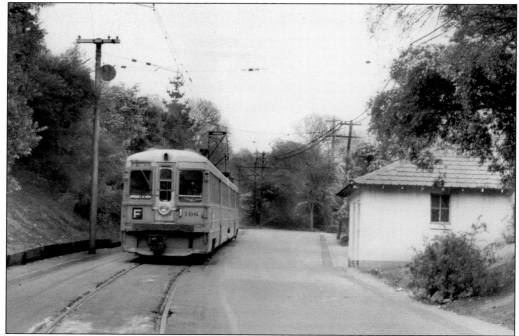

After the July 26, 1941, Berkeley abandonments of the Interurban Electric Railway, the F-train was extended through the Northbrae Tunnel to Solano and the Alameda, where No. 166 awaits another trip to San Francisco in 1948. On a rainy day, F-line passengers will certainly appreciate the shelter that the company provided. (Harre Demorro collection.)

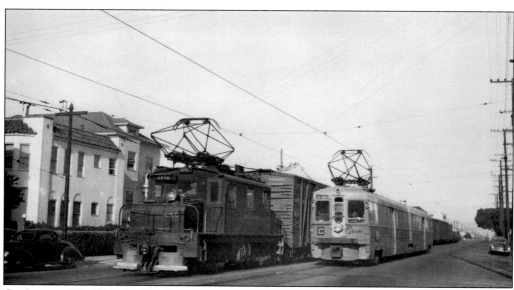

On January 30, 1911, the Key Route signed an agreement with Oakland, Antioch and Eastern that allowed OA&E trains—both freight and passenger—to operate over its Fortieth Street trackage and, as required, to the pier. A single unit, No. 166, working a C-line schedule is passing a Sacramento Northern freight "drag" on Fortieth Street in 1949. (Randolph Brant collection.)

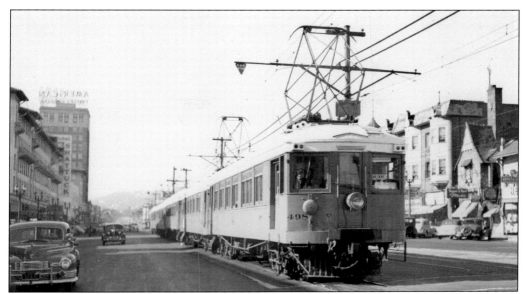

Four of the five ex-Sacramento Northern cars (Nos. 495–499), bright in their National City Lines "fruit colors," are making one of their final trips on the F-line as the "City of Berkeley" in 1949. Postwar ridership was in a rapid and shape decline and that June all of these unique Key cars were withdrawn from service. The missing car is No. 499, which was de-motorized after the war. (Photograph by Tom Gray.)

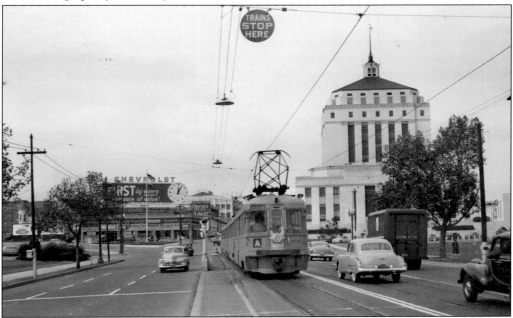

Soon the first big change will occur to transbay service under National City Lines management. A-line service south of Twelfth and Fallon Streets to Havenscourt was replaced on October 30, 1950, by the new K-line bus. Havenscourt-bound Unit No. 182 and its mate are about to cross the Twelfth Street Bridge, whose rebuilding was the cause of the cutback in the summer of 1950. (Randolph Brant collection.)

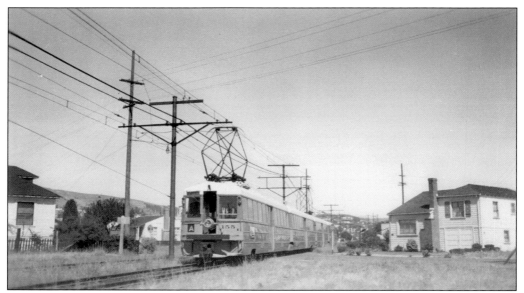

The train door is wide open on Unit No. 155 in an effort to provide some relief from the late afternoon heat for the few sweltering passengers still onboard. The stop for Havenscourt can't come too soon. But for now, NCL-painted No. 155 and its mate are running along former IER trackage on Bond Street, a few minutes away from the terminal and relief, in 1950. (Randolph Brant collection.)

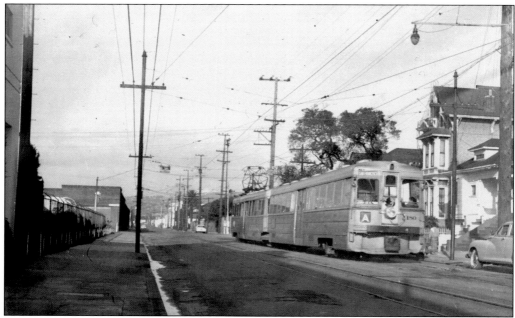

Soon A-train single-unit No. 180 will leave West Oakland's Poplar Street, climb the San Francisco-Oakland Bay Bridge, stop at Treasure Island, and arrive at San Francisco's Transbay Terminal in 1950. The quiet street scene implies a Sunday. On Sundays in the mid-1950s, A-trains leave San Francisco as F-trains, and inbound San Francisco F-trains become outbound A-trains. (Randolph Brant collection.)

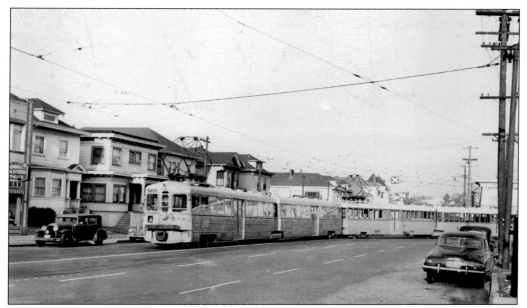

Inbound from Havenscourt, a sparsely patronized A-train, led by Unit No. 174, is turning onto First Avenue from Fourteenth Street, east of Central Oakland in 1950. Reflective of its era, each unit had a smoking and nonsmoking section, with the conductor always stationed in the nonsmoking section, always designated as "B Section." (Randolph Brant collection.)

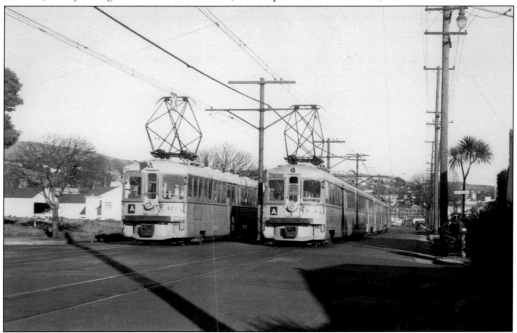

Both straight-side Unit No. 122 and slanted-side Unit No. 184 show off the first generation of National City Lines colors—yellow with a tint of orange and green and white roofs. In order to mask condensation drips, tan soon replaced white as the roof color. The units are on former IER trackage at Sixty-fourth Avenue in 1950. (Randolph Brant collection.)

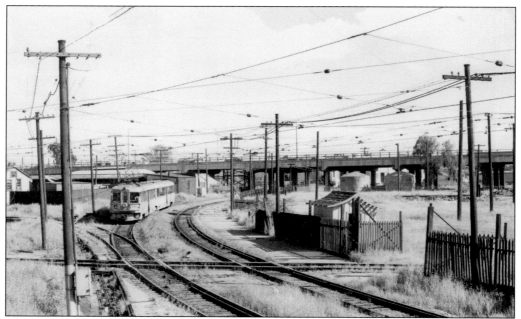

Desolation and weeds predominate the once important Key Route transfer point of Poplar Junction in 1952 as a single-unit, San Francisco–bound A-train slowly transverses the now marginally maintained trackage. The track to the left is for B-line trains and the cross track leads to the Yerba Buena Yard, now replaced by the Bridge Yard. (Randolph Brant collection.)

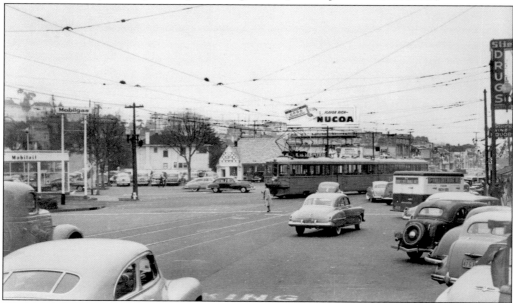

A single-unit B-train, bound for upscale Underhills, is turning on to Grand Avenue in 1954. Close examination of the load shows less than a dozen paying passengers; not enough to cover the wages of the motorman and conductor and the kilowatts consumed. Although this photograph may not reflect accurately Key's ridership pattern, it is symptomatic of the ridership free fall that Key experienced by the mid-1950s. (Randolph Brant collection.)

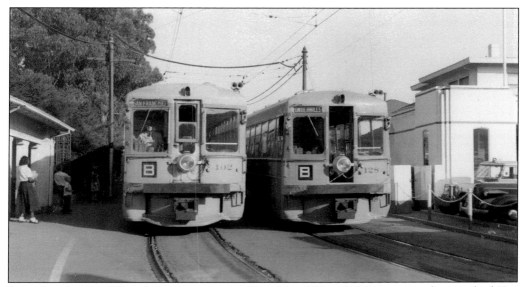

It is a hot day in 1955 and the Key crews on Unit Nos. 102 and 128 are using the standard Key Route ventilation practice—allowing air to enter the passenger compartment through the train doors for the comfort of the few passengers. The skirt on the young lady about to board the San Francisco B-train at Wesley and Lakeshore belies another era. (Walter Rice collection.)

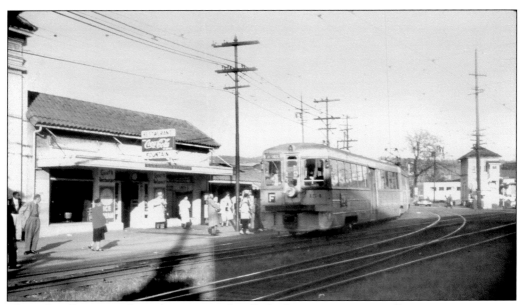

These San Francisco–bound passengers hardly had time to enjoy a coffee or an ice cream at Gust's Restaurant before a train arrived. Fortieth and San Pablo was the stop until 1955 for the Emeryville Ballpark, where San Francisco Seals fans would disembark to see the Seals vanquish (hopefully) their Pacific Coast League rival, the Oakland Oaks. (Randolph Brant collection.)

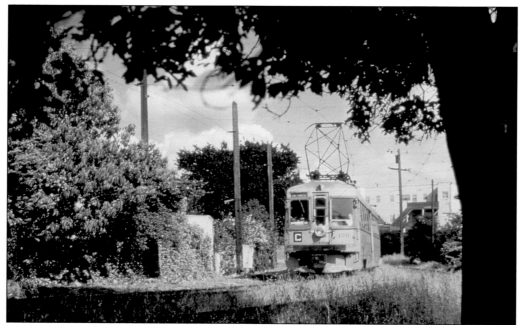

Inbound from Oakland Avenue, Unit No. 126 is cautiously rolling along the weed-infested outer section of the C-line's private right-of-way in the 1950s. Flanked by upscale homes of Piedmont commuters, the right-of-way would be subdivided after abandonment. (Photograph by Fred Matthews.)

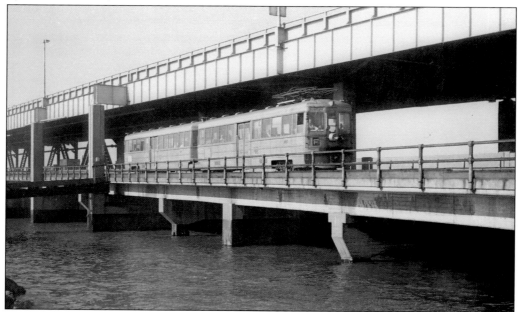

During the 1950s, the F-Berkeley via Shattuck Avenue was Key System's heaviest transbay line. Nevertheless, except for rush hours, only a single unit was required for most schedules. By 1956, when this Unit No. 155 is leaving the Bay Bridge and the third rail territory, approximately half the 88 bridge units have been withdrawn from service. (Photograph by Tom Gray.)

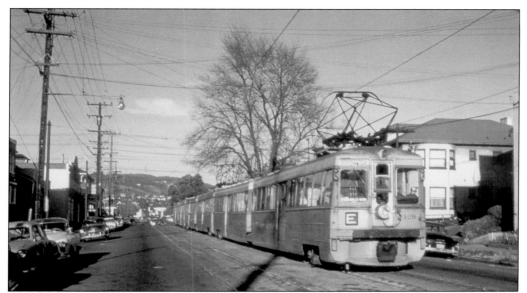

A three-unit evening rush-hour E-train is rumbling along Claremont Avenue toward its terminal on the grounds of the Claremont Hotel. By the time slanted-side Unit No. 129 and its two mates made this 1957 journey—the last full year of transbay rail—ridership on Key's five transbay had declined 85 percent from its 1945 peak. After the rush hour was over, the sparse number of E riders would be transported by motor coach as they would be on Sundays and holidays. (Photograph by Fred Matthews.)

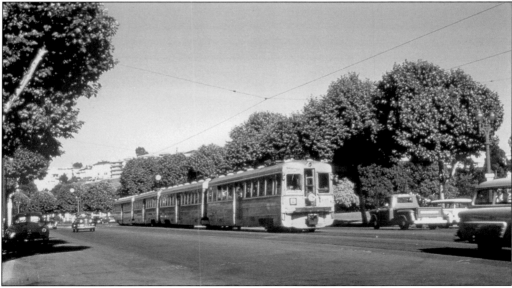

As they run along upscale Grand Avenue in 1957, Underhills-bound B-train Unit No. 135 and its companion are carrying two classes of passengers—San Francisco transbay and local service riders. Passengers in San Francisco boarded by passing a ticket-taker guard before reaching the Transbay Terminal's upper level boarding. Eastbound local service passengers (non-bridge riders) paid their fares as they boarded; whereas westbound local service riders paid upon leaving the train. San Francisco fares were paid after arrival. (Walter Rice collection.)

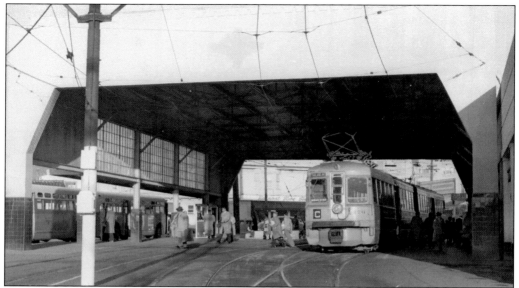

On February 3, 1957, while topcoat-clad commuters race from No. 176, their single-unit C-train, to board connecting General Motors buses at Piedmont Station, management is actively working on strategies to ensure that their entire trip would be made by rudder tire vehicles. After the April 1958 abandonment, Unit No. 176 would continue to carry revenue passengers until 1974—albeit in Buenos Aires, Argentina. The GM buses would visit the scrapper in the early 1960s under the aegis of Key System's replacement, AC Transit. (Stephen D. Maguire collection.)

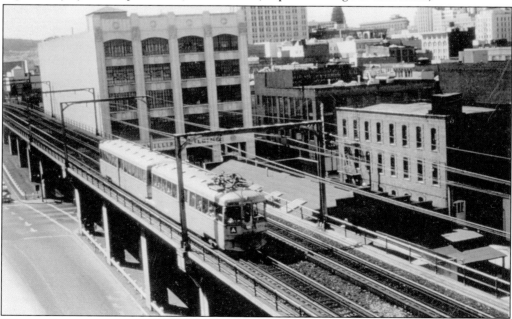

What rail operation carried millions of San Francisco passengers for over 19 years by barely touching any soil of the "metropolis of the west?" As illustrated here by Key Unit No. 172, running on the A-train to central Oakland, most of Key's San Francisco operation was elevated in 1957; the exception being near the Bay Bridge. (Photograph by Fred Matthews.)

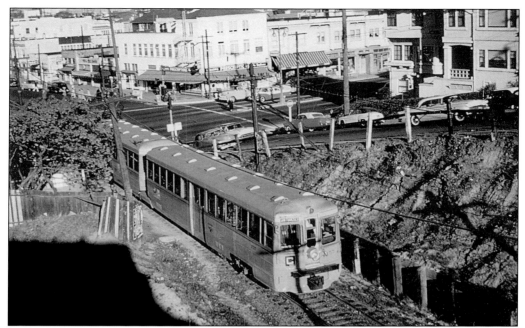

Because of hilly topography, Key constructed a single-track cut to Howe Street, just beyond which the Piedmont Station was built, at Fortieth Street and Broadway. Led by the larger, 74-seat, nonsmoking section (smoking section had 66 seats) single unit, No. 157, this San Francisco–bound C-train is just entering the cut in 1957. (Photograph by Fred Matthews.)

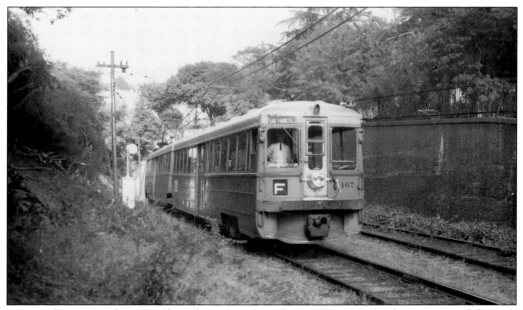

Deep in former Southern Pacific red-train territory, F-train Unit No. 167 has just passed through the Northbrae Tunnel as it approaches the Thousand Oaks terminal in 1957. The motorman opted to wear the railroad engineer's overalls in lieu of the standard navy garb, a discretionary option NCL management allowed. (Photograph by Tom Gray.)

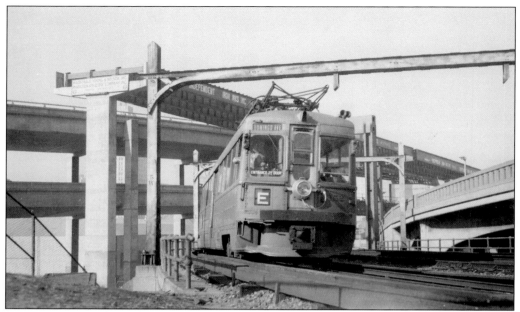

Key System's National City Lines ownership must have been pleased to see freeway construction atop its San Francisco Bridge Railway trackage in 1957. The automobile's ally, the State of California, who wanted to rebuild the Bay Bridge to accommodate more motor vehicles by eliminating the Bridge Railway, provided the final impetus for substitute buses on its transbay rail lines. (Photograph by Tom Gray.)

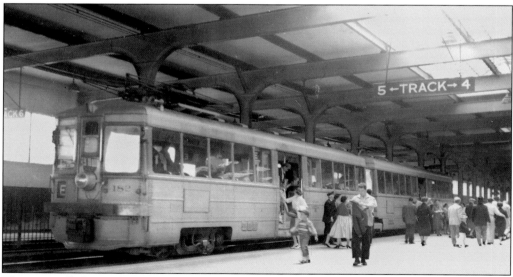

The unusually heavy E-train passenger load disembarking at San Francisco's Transbay Terminal on Saturday April 19, 1958, is because this is the last full day of the Bridge Railway, and these are the last riders. Since both the E- and C-trains were buses at night, passengers of those lines had but a few hours to experience a rail ride. A, B, and F riders could enjoy riding the rails into the wee hours of Sunday morning. (Walter Rice collection.)

The larger nonsmoking section of the bridge units featured leather seats and a conductor's stand with a fare box. The fare box was used for local service riders since San Francisco passengers, regardless of their direction of travel, paid their fares at the East Bay Terminal. (Walter Rice collection.)

When the Bridge Railway was abandoned on April 20, 1958, the bridge trains were replaced by 21 new diesel buses and 60 obsolete, out-of-service gasoline-powered White coaches. Transbay Terminal's six tracks have been replaced by three bus lanes as Key System F-Express Bus No. 2100, one of the new diesel buses, awaits its less-than-excited passengers in 1959. (Walter Rice collection.)

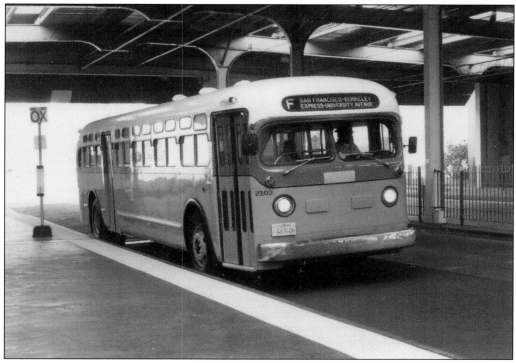

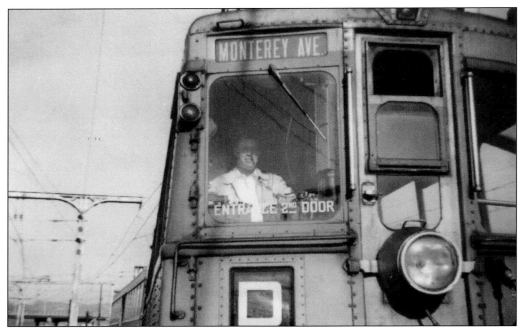

It's late Saturday afternoon, April 19, 1958, and the Bridge Railway only has about 12 hours left. Coauthor Walter Rice arrived at the Bridge Yards to spend the evening on various last runs, and before the end, he proudly occupies the cab of a Key unit. Playing with signage, he has put the unit on the D-train; the never-opened transbay Montclair line over the trackage of the Sacramento Northern Railway with a destination of "Monterey Avenue" for the H–Sacramento Street line that ended service in July 1941. It was a night to remember. (Walter Rice collection.)

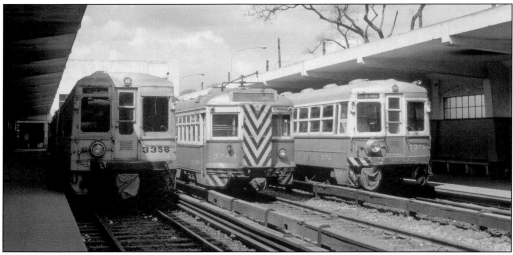

Three expatriate California railcars rest at Frederico Lacroze station in Buenos Aires, Argentina, in late 1972. From left to right are Ferrocarril General Urquiza No. 3356, still in its Key System Transit Lines "fruit salad" colors of yellow, green, and white it wore as Key No. 156; No. 3745, an ex-Pacific Electric "Valley Seven" showing off its new train door to allow the passage of train inspectors; and No. 3376 (Key 176), in the Urquiza's red, cream, and silver colors. (Photograph by John Kirchner.)

Seven

FINAL STOP
BUENOS AIRES

After abandonment of the Key Route's transbay trains, most of the units were fated to the scrapper. However, starting in 1961, a group of 31 cars from the 150–187 Series, which had been previously deeded to the California Toll Bridge Authority, made the long journey south to Argentina, where they saw another 12 years of suburban service in Buenos Aires.

The government-owned Ferrocarril General Urquiza operated a standard-gauge, third-rail suburban electric line running west from the Frederico Lacroze station in Buenos Aires, where it linked up with the city subway system. The Urquiza already had an established record of buying secondhand California interurbans, beginning in 1953 with the acquisition of all 50 Pacific Electric's 1100 Series cars, 28 "Valley Seven" suburban cars, and several PE freight motors. In 1959, the Urquiza picked up 30 PCC cars that had been stored for five years in PE's subway, and tried to integrate them into its fleet. These cars were in poor mechanical condition and did not track well on the Urquiza's wobbly track, so when the state's Key units were offered, they were snapped up.

Ironically, the former Key units replaced newer PCC cars and were soon at home on the Urquiza's less-than-perfect track. The bridge units, however, were considered underpowered, and they had trouble keeping up with schedules. The Urquiza remedied this by adding a traction motor to the center of the non-powered articulated truck.

The Argentines made many modifications to what was once the transportation pride of the Eastshore Empire. Gone were the pantographs, replaced by trolley poles on one end of each articulated set. While third rail provided the power for revenue service, the Urquiza's yards and shop areas worked from overhead wire. The one-time rail fan seat on the left front of each car gave way to an enclosed cab area necessitated by the Argentine system of left-hand running. Operable windows were another innovation, an absolute necessity in the summer heat and humidity of the Argentine Pampa. Some cars had baggage compartments added with side doors. Finally, the headlamps were offset to the right front of each car, located where the Key cars once sported their route boxes.

The Key cars were typically operated in double-articulated sets, and frequently protected off-peak schedules. Most units were painted in the Urquiza's red, cream, and silver, but some operated in "fruit salad" colors right up until the end in 1974, when high-platform Japanese-built MU cars replaced them and their California cousins. About this time, *San Francisco Chronicle* columnist Herb Caen added a humorous concluding note. Poking fun at teething troubles on the Bay Area Rapid Transit System (BART), Caen suggested returning the expatriate cars to California and bringing along Argentine strongman Pres. Juan Domingo Peron to make them run on time.

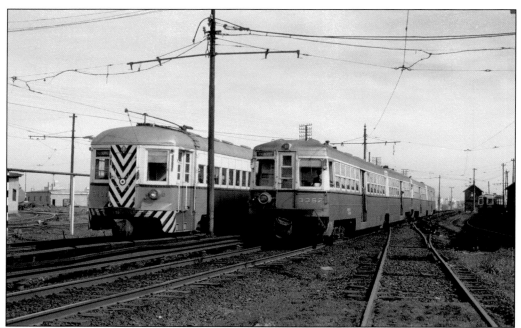

In late 1972, outbound ex-Key Unit No. 162 passes a train of former Pacific Electric 1100s inbound to Buenos Aires at Lynch, the location of the FCGU's main Buenos Aires yard and shops. Because of the company's left-hand operation, the motorman rides at the left front, the former location of the rail fan seat on what is now No. 3362. All former California equipment carried trolley poles to obtain power within the yard. (Photograph by John Kirchner.)

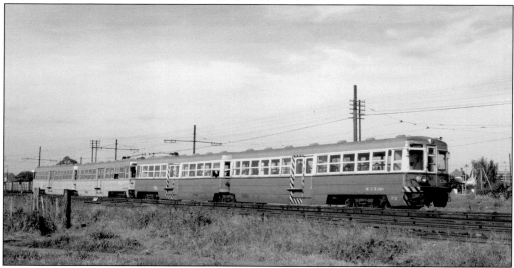

In Buenos Aires, the former bridge units were typically operated in double-articulated sets. Shorn of their pantographs, red-, cream-, and silver-painted Unit No. 3384 (Key No. 184) is coupled to Unit No. 3366 (Key No. 166), whose colors are appropriate for the Eastshore Empire but not the Argentine Pampas. A close examination where the two units are coupled shows they have trolley poles for yard movements. The trolley overhead, visible behind the train, is part of the Lynch freight yard in late 1973. (Photograph by John Kirchner.)

BIBLIOGRAPHY

Arnold, Bion J. *Report on the Improvement and Development of the Transportation Facilities of San Francisco.* San Francisco: March 1913.

Demorro, Harre W. *The Key Route: Transbay Commuting by Train and Ferry, Vols. I and II.* Glendale, CA: Interurbans Press, 1985.

Guido, Francis. "Key System Interurban Lines." *Western Railroader.* February 1972: Vol. 35, No. 2.

J. G. White and Associates. "Report on San Jose Extension of the San Francisco-Oakland Terminal Railways California, December 1912." *Journal II of the Bay Area Electric Railroaders Association.* Rio Vista, California: 2006.

Kirchner, John. "California's Wandering Electrics." *Pacific News.* September 1975.

Rice, Walter, and Emiliano Echeverria. "Why the Octopus Left the Streets of San Francisco." *Journal II of the Bay Area Electric Railroaders Association.* Rio Vista, CA: 2006.

Sappers, Vernon J. *From Shore to Shore.* Peralta Associates Publisher, September 1948.

Walker, Jim. *Key System Album* (Interurbans Special 68). Spring 1978.

Westler, Dudley. "How Key System Operated the Piedmont Shuttle." *Journal II of the Bay Area Electric Railroaders Association.* Rio Vista, CA: 2006.

Discover Thousands of Local History Books Featuring Millions of Vintage Images

Arcadia Publishing, the leading local history publisher in the United States, is committed to making history accessible and meaningful through publishing books that celebrate and preserve the heritage of America's people and places.

Find more books like this at
www.arcadiapublishing.com

Search for your hometown history, your old stomping grounds, and even your favorite sports team.